BLACK AMERICA SERIES

AFRICAN AMERICANS
IN DOWNTOWN ST. LOUIS

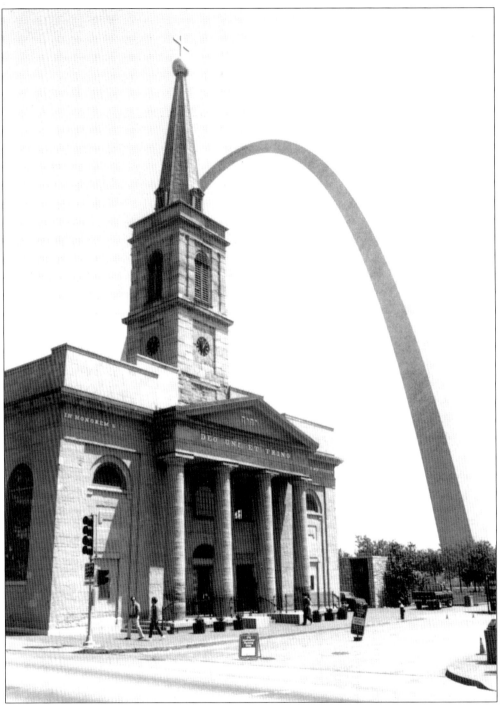

The old and the new are here to ever remind us of the role African Americans have played in our city's history. It was William Johnson, a free African American who put the last stone in place on the old cathedral and African American activist Percy Green who climbed the Gateway Arch during construction to remind us that the battle for equal rights is ongoing. (Photograph by John A. Wright.)

BLACK AMERICA SERIES

AFRICAN AMERICANS IN DOWNTOWN ST. LOUIS

John A. Wright Sr.

ARCADIA

Published by Arcadia Publishing,

Charleston SC, Chicago IL, Portsmouth NH, San Francisco CA

Printed in the United States of America

Library of Congress Catalog Card Number: 2003107580

For all general information contact Arcadia Publishing at:
Telephone 843-853-2070
Fax 843-853-0044
E-Mail sales@arcadiapublishing.com
For customer service and orders:
Toll-Free 1-888-313-2665

Visit us on the Internet at http://www.arcadiapublishing.com

This book is dedicated to Charles Brown and Doris Wesley,

two true keepers of the flame.

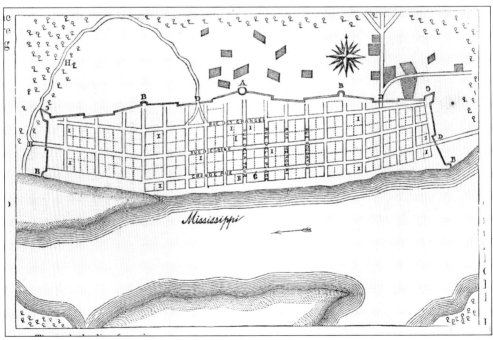

This map of St. Louis was drawn by Auguste Chouteau in 1764. (Courtesy of the Mercantile Library.)

CONTENTS

ACKNOWLEDGMENTS

I would like to give a special thanks to Pam Niehaus and my wife Sylvia for assistance in editing this book. Special words of appreciation go to Charles Brown at the Mercantile Library; Doris Wesley at the University of Missouri, Western Historical Manuscript Collection; Robert Byrne, Editor of the St. Louis employee newsletter; Duane Sneddeker of the Missouri Historical Society; Sharon Huffman of the St. Louis Public Schools; and historians James Vincent and Billye Crumpton for ongoing and never ending support and for always being available when needed.

Special thanks also go to the following individuals and institutions for their help and support in making this book possible. The individuals are: State Senator John Bass, Edward and Brenda Tripp, Doris Coleman, Jennifer D. Ross, Reverend Dr. Robert C. Scott, Reverend Alvin L. Smith, Miki Brewster, Carol Prieto, John and Juanita Doggett, Jeffery Fister, Lois Conley, Dianne White, Yvonne Samuel, Mary Seematter, Vitilas "Veto" Reid, Alice Warren, James Buford, Henry Givens, Henry Shannon, James Vincent, Frank Richards, Theodore Savage, Cosy Marks, Betty Wheeler, Donald Suggs, Wiley Price, Earl Wilson, Jennifer Ross, Carolyn Toft, Sister Mary Stueber, Ella Brown, Jacquelyn Ervin Creighton, Marsha Leonatti, Charles Shaw, Olivia Blackmore, Richard Hudlin, Margaret Bush Wilson, Greta Wilkinson, Frankie Freeman, Randolph Clay, Jamie Graham, Frederick and Patricia McKissack, Randy McGuire, Richard Deposki, Gregory Carter, Virvus Jones, Pearlie Evans, Rita Holmes Bobo, and Nancy Merz. The institutions are: St. Paul AME Church, All Saints Episcopal Church, Washington University Archives, St. Louis University Archives, Denver Public Library Archives, University of Missouri-Western Manuscript Collection, St. Louis Central Public Library, *St. Louis American* newspaper, St. Louis Public Schools Archives, Sisters of Franciscan Archives, Virginia Press, Missouri Historical Society, Midwest Regional Jesuit Archives, Union Memorial Methodist Church, Central Baptist Church, Mercantile Library, Urban League of Metropolitan St. Louis, City of St. Louis, Julia Davis Library, Black World Wax Museum, St. Louis Post Dispatch, The Landmark Association of St. Louis, Lincoln University, Murphy Park, Callaway County Historical Society, Julia Davis Branch St. Louis Public Library, Elijah P. Lovejoy Society, and St. Louis Gateway Classic. If anyone's name was omitted, please accept my apology. You know who you are and what your contribution has added to this publication.

(Opposite photograph courtesy of the St. Louis Public School Archives.)

INTRODUCTION

African Americans have played a vital role in the history of downtown St. Louis since its beginning. However, for many years their contributions have been ignored. Textbooks, written history, and popular accounts for the most part have omitted, distorted, or stereotyped African Americans.

It is the hope that this book will help all who read it to regard African Americans as important contributors, who under the most difficult conditions and circumstances, have added greatly to the history and culture of St. Louis and the country. By filling in some of the gaps in St. Louis' history, this book should help replace omission with knowledge and myth with reality.

African Americans have left an indelible mark in St. Louis and American history, from the days of slavery and Jim Beckworth, one of the founders of Denver, Colorado, and William Wells Brown, America's first black novelist, to the present day. In addition, monumental court cases such as *Dred Scott v. Irene Emerson*, *Shelly v. Kramer*, *Lloyd Gaines v. Canada,* and *Jones v. Alfred H. Mayer Co.* have had a profound impact on the city and country. Downtown St. Louis has also been the home to many unforgettable faces, places, and events that have shaped the St. Louis and American experience for all, such as entertainers Josephine Baker, Scott Joplin, and W.C. Handy and such memorable folk ballads as "Frankie and Johnny," "Stackerlee," and "Brady and Duncan."

Today, most traces of early African American presence in downtown St. Louis have disappeared from the city's landscape, except for a few churches that have remained and a few streets with name changes. However the most important things that will never change are the contributions and impact African Americans have had on the city and nation.

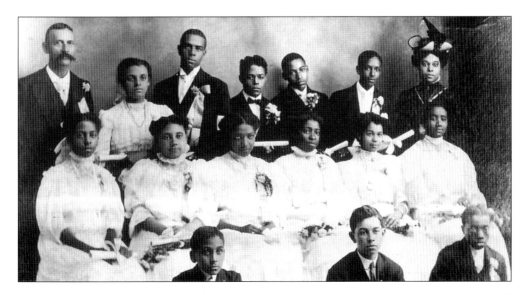

Nun and child patient are pictured at St. Mary's Infirmary. (Photograph courtesy of the Sister of Franciscan Archives.)

One

THE BEGINNING

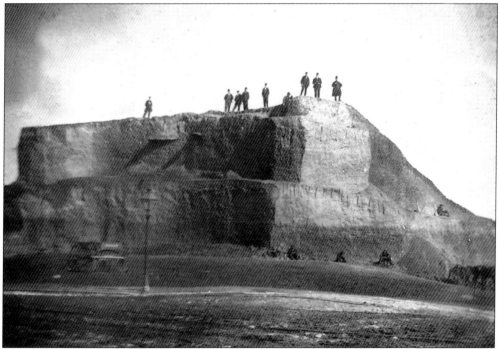

African Americans and their ancestors have been a vital part of the history of America and St. Louis since their beginning. No one knows for sure when the first Africans arrived in the Western Hemisphere. Peter Martyr, historian of Balboa's 1513 expedition where Balbo discovered the Pacific Ocean, writes that Balboa found blacks at war with the Indians and thought they may have come from Ethiopia. Columbus on his third voyage heard stories of Negroes who had come from the south and southeast to Hispaniola. Historians Ivan Van Sertima, a Rutgers University professor, and Leo Weiner, a Harvard University professor, have provided some evidence and theories that the Indian Mounds in the St. Louis area may have been influenced by Africans. They also state similar mounds were used for protection of Mandingo trading posts in West Africa centered in the upper Niger Valley. We may never know for sure when the first Africans arrived in the area. However, we do know that in 1719 blacks entered into what is now known as Missouri, unwilling participants in a new French mining venture. (Photograph of Indian Mound in 1870 courtesy of the Mercantile Library.)

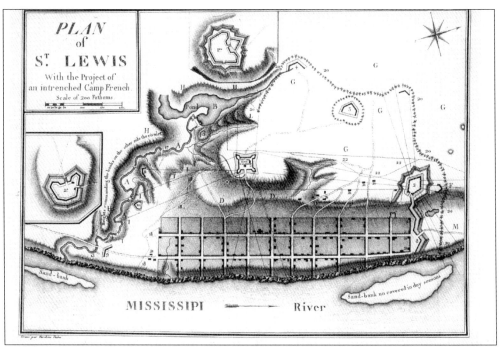

St. Louis was founded in 1764, a product of competition between European nations over control of the Mississippi Valley. From its founding, St. Louis has served as the "Gateway to the West" for African Americans. Free blacks and slaves were among the early settlers of the village. According to the 1799 census, the St. Louis population included 56 free blacks, 268 slaves, and 601 whites. (Map courtesy of the Mercantile Library.)

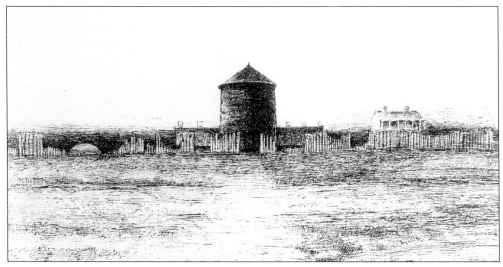

Blacks played a vital role in the development of the early village. On May 25, 1780, Fort San Carlos (located around Broadway and Market and Fourth and Walnut Streets), pictured here, was saved when a slave named Louis alerted the villagers and spoiled a large-scale attack by the British and an estimated 600 Sioux, Sac, Fox Potawatomi, Winnebago, and Chippewa. By repelling the attack the villagers put an end to the British campaign to take over the Mississippi Valley. (Photograph courtesy of the Mercantile Library.)

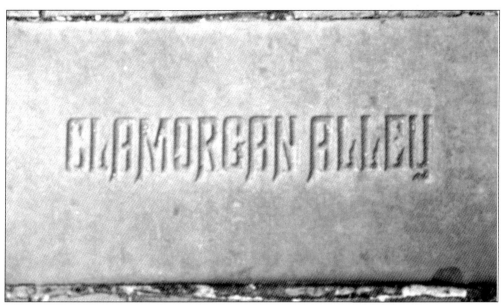

Clamorgan Alley, originally called "Commercial Alley," marked by this sidewalk engraving, is named for Jacques Clamorgan, a West Indian native who arrived in St. Louis in the 1780s. He was a fur trader, merchant, financier, and land speculator who owned land in what is now Laclede's Landing. His home was on the site of what is now the Peper Tobacco Company, 701-17 North First Street. In 1804, he was appointed judge of the Court of Common Pleas and Quarter Sessions and rented his house to the government to be used as a jail. (Photograph by John A. Wright.)

In 1796 Jacques Clamorgan was given the title to a considerable amount of land in Missouri and Arkansas and encouraged by Charles Dehault Delassus, Lieutenant Governor of New Madrid and its dependencies, to establish a rope factory for the use of Spain's navy and Havana. Clamorgan was in every way an enterprising individual. Besides his rope making enterprise, he and Jean Baptiste Point DuSable developed a thriving trading business. (Document courtesy of Mercantile Library.)

TITLE PAPERS

OF

THE CLAMORGAN GRANT,

OF

536,904 ARPENS OF ALLUVIAL LANDS

IN

MISSOURI AND ARKANSAS.

NEW-YORK:
PRINTED BY T. SNOWDEN, 58 WALL STREET.
1837.

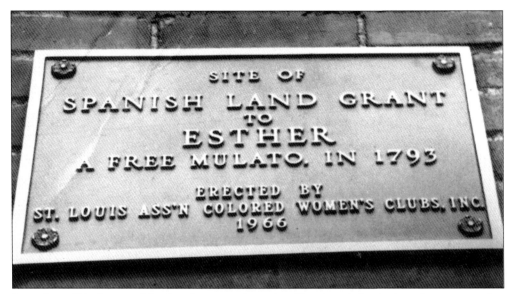

A number of blacks owned land and property from the village's early beginning; the exact number is unknown. Esther, a former of slave of Clamorgan, petitioned Spain in 1793 and received a land grant at 723 North Second Street. Another black woman, Jeanette Forchet, owned property on Church Street. She and her husband received one of the original St. Louis town lots and a farm lot in the common fields in downtown St. Louis. Over the years her descendants subdivided the town lots among themselves and eventually sold it to developers. (Photograph by John A. Wright.)

In 1804, President Thomas Jefferson commissioned the Meriwether Lewis and William Clark expedition to explore the land we now know as the Louisiana Purchase. The lone black man and one of the most valuable men on the expedition was York, William Clark's slave. He played a major role in winning the friendship of the Indians. This event was made possible by Pierre Dominique Toussaint L'Ouverture, a Haitian patriot who in 1791 led a revolt against the French and set in motion events that culminated in the Haitian revolution and independence. The event in Haiti brought about a defeat of the French army and caused Napoleon to sell this territory to the United States for $15,000,000. (Photograph by John A. Wright of Hasan Davis, Missouri Humanities Council, Chautauqua actor.)

Two

SLAVERY
THE PECULIAR INSTITUTION

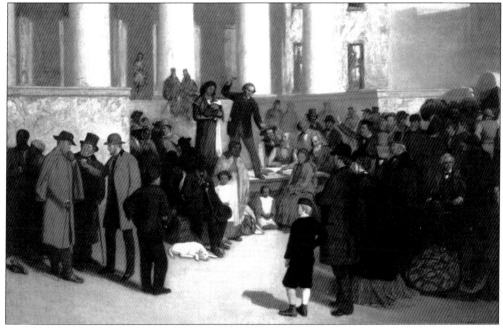

Philippe Francois Renault is traditionally considered to have introduced black slavery to Missouri in 1720. It is written that he brought 500 blacks with him from Santo Domingo to work the lead mines in the Des Peres River section of what is now St. Louis and Jefferson Counties. Slaves were sold on the steps of the old courthouse, pictured here, until 1861. Since St. Louis was not a farming community, there never was a great need for slave holders to have large number of slaves, so many slaves were rented out to others or allowed to rent themselves out to perform odd jobs.

Not all blacks were slaves. Some were born free, given their freedom, or purchased their freedom while working after hours. Although slavery presented great obstacles, many blacks went on to become national and international personalities who made great contributions to the city and country. (Photograph courtesy of the Missouri Historical Society.)

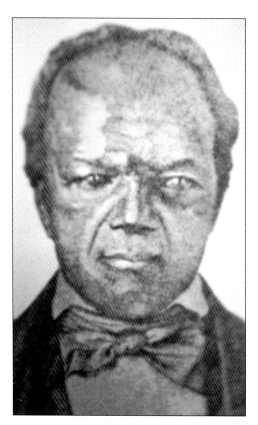

There were a number of free famous African Americans in St. Louis prior to the Civil War. One was the Reverend John Berry Meachum, founder of First Baptist Church. He owned two steamboats on the Mississippi River. One of his boats was anchored on a sandbar and used as a school to teach slaves the rudiments of reading and writing. He also owed a barrel factory where about 20 slaves were employed. Meachum, after purchasing the slaves, would allow them to work to pay him back. Both he and his wife were supporters of the "Underground Railroad."(Photograph courtesy of Central Baptist Church.)

One of the conductors of the Underground Railroad was Peter Hudlin, pictured here with his daughter. From his home in now the 1400 block of Thirteenth Street, just south of the Greyhound bus terminal, he uncrated run-away slaves, fed them, and provided space for them to rest in his basement until nightfall. He would then recrated them and, under cover of darkness, take them by wagon across the river to another underground route near Alton, Illinois. (Photograph courtesy of Richard A. Hudlin, www.saint-louis.net/cr-peter.htm.)

Achieving freedom was not an easy task as one can discover from reading Lucy Delaney's book, *From the Darkness Cometh the Light; or, Struggles for Freedom.* In her book, she describes her life as a slave in St. Louis and the successful legal action that her mother undertook to win her freedom. Delaney went on to become a successful seamstress and in 1849 married Zachariah Delaney, who worked as a porter, laborer, and janitor in St. Louis. In 1890 they lived at 1241 Gay Street. (Photograph engraving courtesy of the Mercantile Library.)

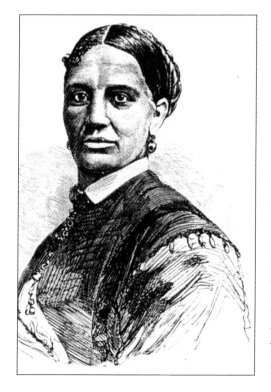

Another author and famous African American was Elizabeth Hobbs Keckley, who lived at 5 Broadway. Keckley was born a slave in Virginia and grew up to become a dressmaker to first lady Mary Todd Lincoln. In her 1868 autobiography, *Behind the Scenes: Thirty Years a Slave and Four in the White House,* she describes her life and career. In 1855, with the help of some female patrons, she purchased freedom for herself and her son George for $1200. (Drawing from reprint of *Behind the Scenes: Thirty Years a Slave and Four in the White House,* courtesy of the Ferguson-Florissant School District Human Relations Committee.)

15

The 1858 St. Louis directory listed two slave dealers, Corbin Thompson at 3 South Sixth Street and Bernard Lynch at 100 Locust Street. In his advertising, Thompson claimed that his slave pen had "a high and healthy location with ample room." Lynch engaged in the slave trade for many years in the city. He first operated out of his facilities at 100 Locust Street midway between Fourth and Fifth Streets. When his business out grew those quarters, he purchased the Fifth and Myrtle site in 1859, installing barred windows, bolts, and locks to convert it to a secure prison. (Advertisement courtesy of the St. Louis Public Library.)

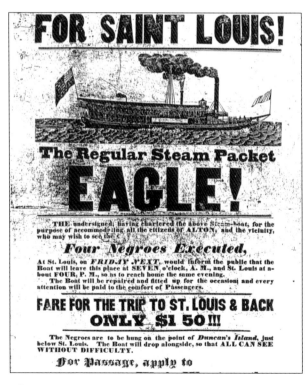

In early St. Louis, blacks were never guaranteed protection by the law. In 1836, Francis McIntosh, a free mulatto, was burned alive—without a trial—for the killing of a police officer. On July 9, 1841, approximately 75 percent of St. Louis came out to watch the execution of four blacks, one slave and three free men, on Duncan Island. The men were charged with the murder of two white bank tellers, bank robbery, and arson. None of the men testified in their own defense. Despite their attorney's objections, all four were found guilty and hung. Their heads were later placed on display in the front window of Corse's Drug Store at 69 North First Street to send a message of intimidation to the black population. (Advertisement courtesy of the Saint Louis Public Library.)

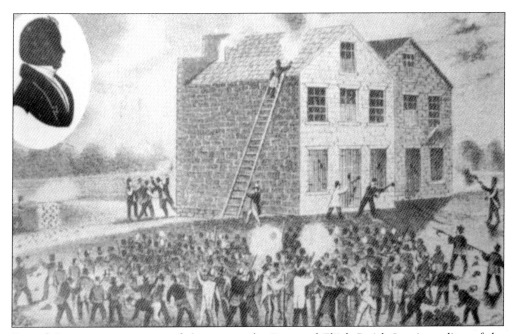

One of the strong opponents of slavery was the Reverend Elijah Parish Lovejoy, editor of the Presbyterian newspaper, the *St. Louis Observer*. Lovejoy used the newspaper to draw attention to the evils of slavery. After the lynching of Francis McIntosh in 1836, Lovejoy published a detailed account of the tragedy, entitled "Awful Murder and Savage Barbarity." Because of his outspoken views, Lovejoy's enemies broke into his office three times during the week. He later moved to Alton, Illinois where he was killed in this warehouse and became "freedom's first martyr." (Drawing courtesy of Central Baptist Church.)

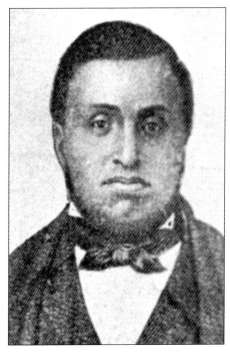

John Richard Anderson was present the night of November 7, 1837, when Reverend Elijah Parish Lovejoy was killed by a pro slave mob in Alton, Illinois. Anderson was type-setter for Lovejoy and many felt his experiences with Lovejoy prepared him for his later work as pastor of Central Baptist Church. Anderson, before the Civil War, spoke out against slavery and drew crowds of whites to hear him preach. He was a correspondent of John Brown and Frederick Douglass. He died suddenly in 1863 when a druggist made a mistake in filling his prescription. (Photograph courtesy of Central Baptist Church.)

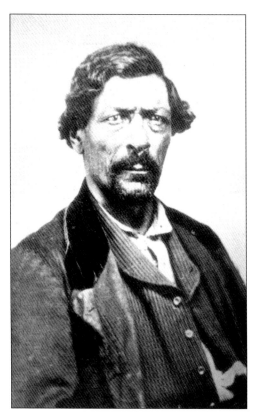

A renowned mountain man was James Person Beckworth, who worked as an apprentice in the blacksmith shop of John Sutton and George Casner at 94 South Second Street. After a quarrel with Casner in 1817, Beckworth went on to become an explorer, guide, and scout. He spoke Indian dialects, as well as French and Spanish. In 1850, he discovered a passage though the Sierra Nevada Mountains, which now bears his name. Because of his good relationship with the Native Americans, he became chief of the Crow Indians. (Photograph courtesy of Denver Public Library.)

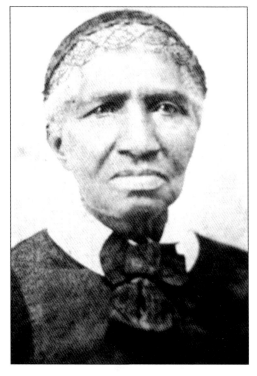

Clara Brown, pictured here, was a woman of great courage and determination. She arrived in St. Louis at age 55 in the late 1850s, after being freed from slavery. She went on to become one of the leading citizens of Central City, Colorado. One day while working as a cook, she heard about a wagon train headed for Colorado and signed on as cook and laundress. Once in Colorado, she managed to save $10,000, which she invested in Colorado real estate and mining claims. She later traveled to Virginia and Kentucky and found 34 family members and 16 free slaves and brought them back to Colorado. (Photograph courtesy of Denver Public Library.)

William Wells Brown was born a slave in Kentucky in 1817. He moved to the St. Louis area with his master's family. Brown was hired out in turn as a hotel keeper's servant, steamboat steward, and a press operator in the printing office of Elijah Parish Lovejoy. Wells went on to become a prominent anti-slavery spokesman, an author in the United States and England, and America's first black novel writer. His best known book is his autobiography, the *Narrative of William W. Brown, a Fugitive Slave*. (Drawing courtesy of the Missouri Historical Society.)

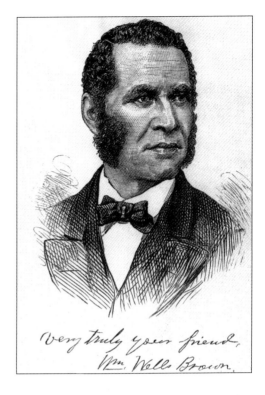

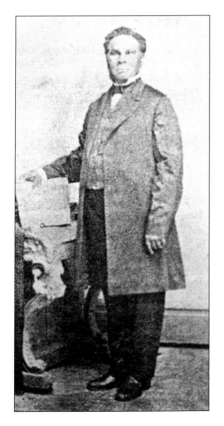

Another prominent individual during the slave era was Reverend Jordon Early, a circuit-riding minister for the African Methodist Episcopal Church. He was self-educated and embroiled in the perilous, toilsome occupation of establishing a network of AME congregations throughout the Midwest. He served as pastor of St. Paul AME Church from 1840 to 1842. Early married Sarah Jane Woodson in 1862 after his first wife Louisa Carter died. Sarah Jane was the daughter of Tom Woodson, the first son of President Thomas Jefferson and Sally Hemings. (Photograph courtesy of Frederick and Patricia McKissack.)

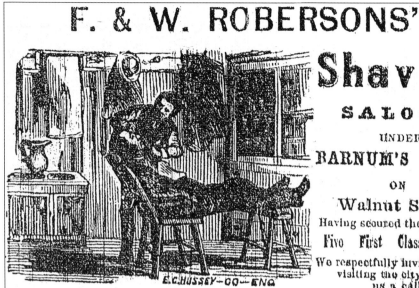

Barbershops were one kind of business opportunity available to free blacks in antebellum St. Louis. According to Cyprian Clamorgan in his book *The Colored Aristocracy of St. Louis,* "A mulatto takes to razors and soap as naturally as a young duck to a pool of water, or a strapped Frenchman to dancing; they certainly make the best barbers in the world . . . " Clamorgan also proclaimed that the moneyed of St. Louis refused to go to white barbers. The above is an advertisement for F.&W. Roberson Shaving Saloon. (Advertisement courtesy of the St. Louis Public Library.)

Two of the grandsons of Jacques Clamorgan specialized in the "most fashionable" imported perfume and toiletry articles. Clamorgan's shop reportedly had private baths with tubs of Italian marble and chairs of mahogany. It was stated also that mirrors covered the walls and the water was as clear as crystal, having been clarified by the barbers. St. Louis water was drawn from the Mississippi River and was usually anything but clean. This advertisement is from J.N. Taylor, St. Louis Business Directory (St. Louis 1850). (Advertisement courtesy of the St. Louis Public Library.)

Pelagie Aillotte Rutgers, pictured here, was a member of St. Louis' mid-19th century black elite. She had substantial real estate holdings in the city. She became a major St. Louis landholder who rented commercial buildings and tenements on her land to white businessmen. Estimates of her wealth ran as high as $500,000, making her the richest black in the city. Her first husband was St. Eutrope Clamorgan, son of Jacques Clamorgan. However, she acquired her property when she married Louis Rutgers. Rutger Street is named for her family. (Photograph courtesy of James Vincent.)

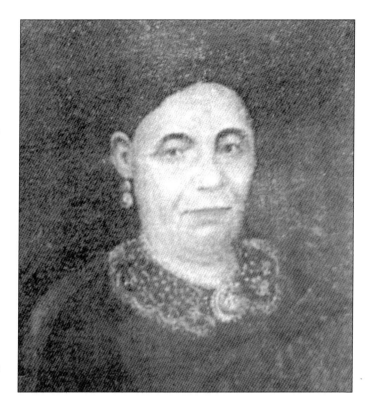

The year Dred Scott died, 1853, saw the publication of a gossipy little book, *The Colored Aristocracy,* by one of the upper-class free blacks in St. Louis, Cyprian Clamorgan. Clamorgan claimed in 1858 that free blacks in St. Louis controlled several million dollars worth of real and personal property. The colored aristocracy was made up primarily of light-skinned mulattoes who principally resided around several streets in south St. Louis. (Photograph courtesy of Billye Crumpton.)

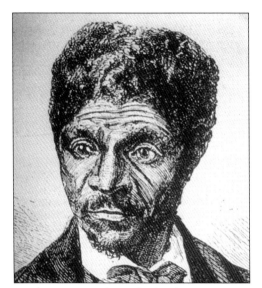

Dred Scott was a slave who lived in St. Louis. He was taken by his owner to live in free territories. Upon his return to St. Louis, he sued to obtain freedom for himself and his wife, Harriett. He lost his case, and the Supreme Court declared in 1857 that a slave had no legal rights to sue in the courts. After the court decision, ownership of the Scotts was transferred to St. Louisan Taylor Blow, who freed them in 1858. This decision was a major contributing factor to the outbreak of the Civil War in 1861. (Drawing from *Frank Leslie's Illustrated Newspaper*, June 27, 1857.)

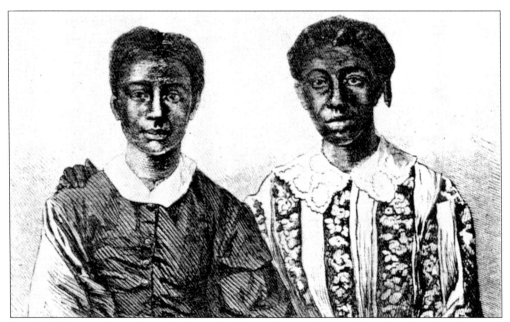

Dred and Harriett Scott, above, had two daughters Eliza and Lizzie. Eliza, their first daughter, was born aboard the steamboat "Gipsey" in October, 1838, while it was on the Mississippi River in "free" northern waters. Lizzie was born about 1845 at Jefferson Barracks in Missouri. Eliza died early in her teens. Lizzie lived in St. Louis until 1881. She married Wilson Madison of St. Louis. They have a grandson, John Madison, who presently lives in St. Louis County. (Drawing from *Frank Leslie's Illustrated Newspaper*, June 27, 1857.)

At a house on Seventh and Lucas Avenue in 1846, Moses Dickson and 13 men organized a secret society called the Knights of Liberty to enlist and arm southern slaves for insurrection to end slavery. When the Civil War started, the men held off their plans and agreed to organize and fight with the Union forces. After the war, Dickson returned to St. Louis and became an ordained minister in the African Methodist Episcopal Church. Dickson is buried in Father Dickson Cemetery at 845 South Sappington Road, which is named for him. (Photograph courtesy of Billye Crumpton.)

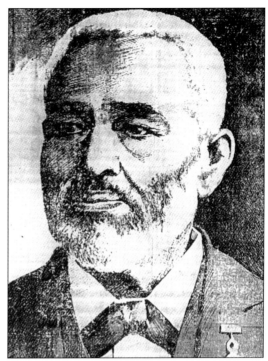

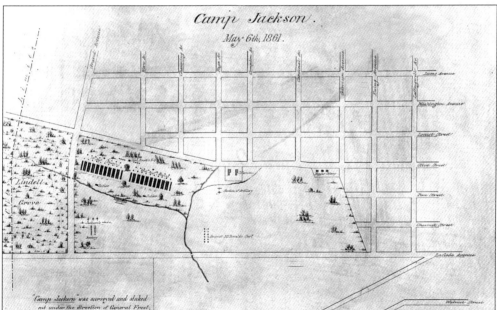

During the Civil War, Missouri remained a slave state loyal to the Union. Camp Jackson, pictured here, bounded roughly by Garrison Avenue on the east, Olive on the north, Grand Avenue on the west, and Laclede, was considered pro-Confederate. The small parcel of land in the northeast corner of the camp was called "Nigger Colony" and used to house African Americans. The camp was named for pro-Confederate Governor Claiborne Fox Jackson. The first black Missouri regiment was recruited in 1863 at Schofield Barracks at 119 Chouteau Avenue. (Map courtesy of Mercantile Library.)

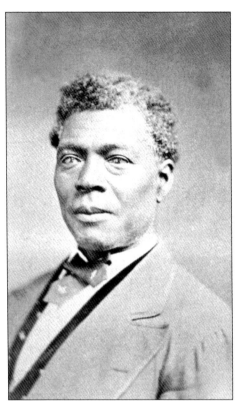

On the evening of June 10, 1861, Archer Alexander, a slave, learned that rebel sympathizers had sawed the timbers of a railroad bridge near St. Louis. At the risk of his own life, he walked five miles to warn Union forces who were scheduled to cross the bridge that night into Missouri. The bridge was repaired and a disaster averted. Suspected of being the informer, Alexander decided to go for freedom and ran away and was befriended by Reverend William Elliot, who later became one the founders of Washington University. (Photograph courtesy of Washington University Archives.)

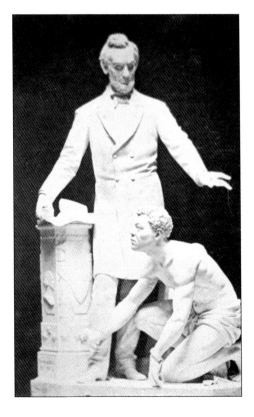

Alexander's deed went unsung until he received a small measure of immortality when he served as the model for the famous emancipation monument in Washington, D.C. Freedom's Memorial Statue, cast in bronze, depicts President Lincoln freeing a slave (Alexander). In 1938, the monument was pictured on a three-cent stamp commemorating the 75th anniversary of emancipation. (Photograph courtesy of Washington University Archives.)

Three

FROM HARD TIMES TO HOPE

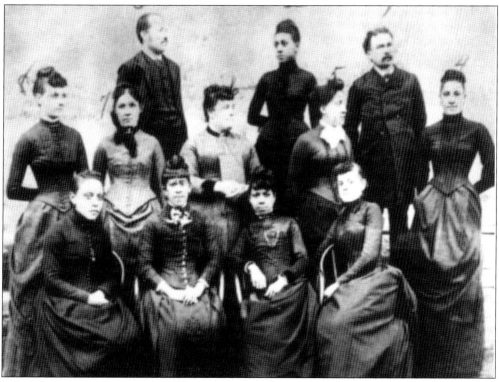

Slaves in Missouri gained their freedom 11 months before the ratification of the Thirteenth Amendment to the Constitution. According to the January 19, 1865 issue of the *St. Louis Daily Press,* there was a great celebration at Fourth Street and Washington Avenue by the African Americans in the city. The end of the Civil War brought many challenges and opportunities to a free black population. Post-Civil War St. Louis saw the legalization of education for blacks, but it also witnessed segregation in both education and religion because of deep white prejudice. Equality of opportunity was talked of more than practiced. Most blacks continued to be employed in menial occupations. However, blacks could now begin to develop more stable families, churches, and business relationships and organize, gain strength, and prepare for the coming struggle for equality. (Early Sumner High School faculty photograph courtesy of the St. Louis Public School Archives.)

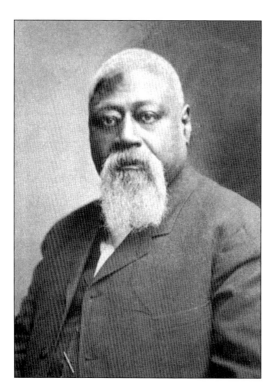

James Milton Turner was an individual who refused to accept the status of inferiority. In a brief 25 years, he rose from slavery to freedom and statewide prominence. By the age of 31, he had been appointed minister resident and consul general of Liberia. He was the first Missourian to receive a U.S. diplomatic post. After the Civil War, the Missouri legislature adopted a new constitution, which provided for black children to be educated. To help achieve this goal, Governor C. Fletcher appointed Turner to the position of assistant superintendent in charge of post-war black schools. (Photograph courtesy of Callaway County Historical Society.)

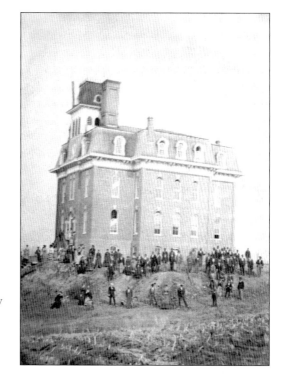

After the Civil War, James Milton Turner joined Captain Charlton H. Tandy and the Reverend Moses Dickson in raising money for Lincoln Institute, known now as Lincoln University. They received $5,000 from the black soldiers of the 62nd Colored Infantry of Missouri and $1,400 from the 65th Colored Infantry of Louisiana. It is reported that Jesse James gave them $1,000. For many years Lincoln University was the only public institution of higher education in Missouri that blacks could attend. (Photograph courtesy of the St. Louis Public Library.)

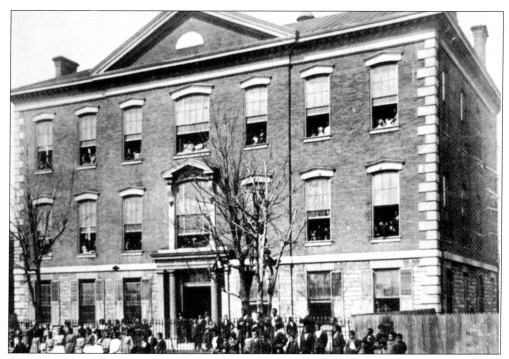

In 1875, the first high school classes for blacks were held in an elementary school, but were discontinued within a month by the school board. However, they were resumed after the state legislature directed the city's school board to provide a high school for black children. The board then designated a formerly all-white elementary school the "High School for Colored Students." The 12-room building pictured here became Sumner High School, the first high school for African Americans west of the Mississippi River. In the early days of the school it was mainly an elementary school with most of its student body in the first four grades. (Photograph courtesy of the Mercantile Library.)

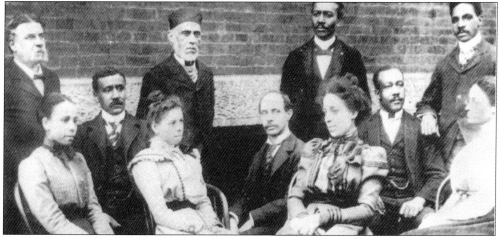

As the first high school west of the Mississippi River for black students, Sumner attracted some outstanding teachers. Some of the early staff is pictured here with Principal Oscar Waring, standing on the far left. For the first two years the school was staffed by white teachers. (Photograph courtesy of John A. Wright.)

27

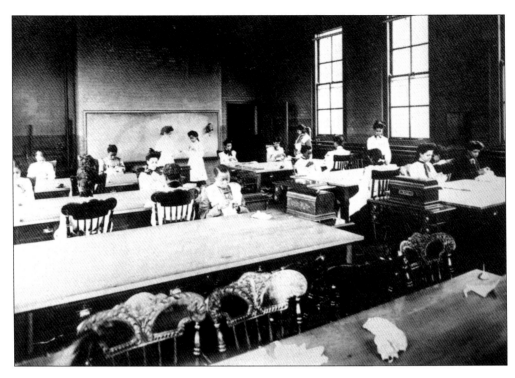

Sumner students were offered a wide range of curriculum offerings. These students are studying domestic science activities. (Photographs courtesy of the Western Manuscript Collection, University of Missouri-St. Louis.)

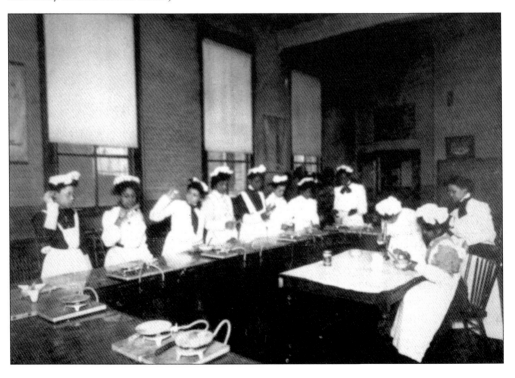

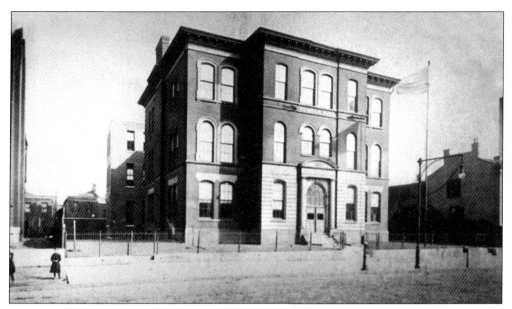

In 1895 Sumner High School was relocated from its previous location on Eleventh and Spruce to this larger facility at Fifteenth and Walnut Streets. This building was an improvement over the earlier one, but it still lacked an assembly room, a gymnasium, a library, and other facilities. Black parents complained, and in 1910 Sumner moved to its present location on Cottage Avenue in the Ville. (Photograph courtesy of the Western Manuscript Collection, University of Missouri-St. Louis.)

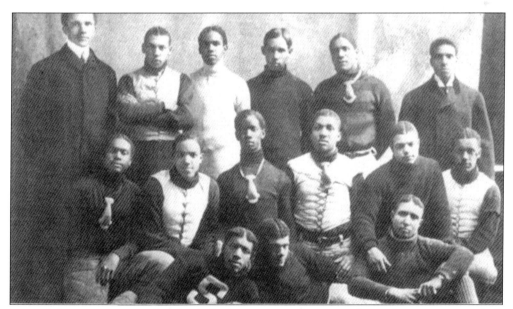

Pictured here is Sumner's first football team, organized in 1902 by Professor E.C. Campbell. Practices were held three times a week in Forest Park. In the early days, Sumner played colleges Fisk and Lincoln University. Lincoln was never able to beat Sumner. Eventually, the two schools met and Lincoln decided it was beneath the dignity of a college to play a high school. (Photograph courtesy of Sumner High School.)

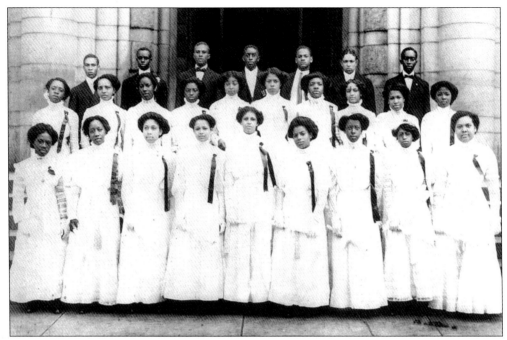

Pictured here are the 1909 Sumner High graduates. The first graduates of the school were John Pope and Emma Vashon in 1885. Vashon was a member of the same family as John B. and George Vashon for whom Vashon High School was later named. (Photograph courtesy of the Julia Davis Library.)

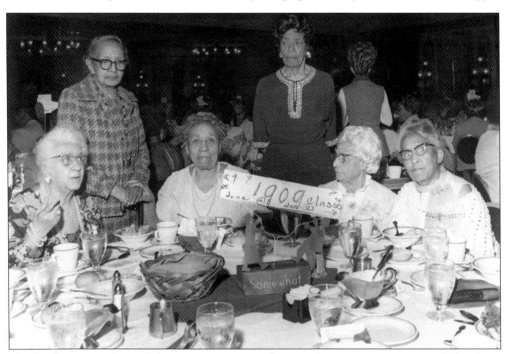

The last living members of the 1909 Sumner graduating class, Percy Gentry, Maudelle Oliver, Julia Davis, Mabel Burns, Marguerite Stanford, and Noneka Douglass, are pictured here at the school's centennial celebration in 1975. (Photograph courtesy of the Julia Davis Library.)

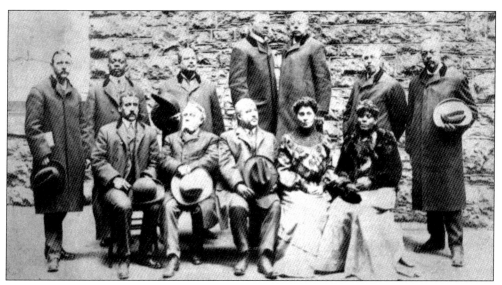

These pioneer school administrators in the St. Louis public schools include four for whom schools were later named. From left to right are: (seated) James L. Usher, Oscar M. Waring, Arthur D. Langston, Eliza M. Armstrong, and Georgiana Whyte; (standing) Charles Brown, J. Arthur Freeman, John B. Vashon, Richard Cole, David E. Gordon, and John A. Agee. (Photograph courtesy of St. Louis Public School Archives.)

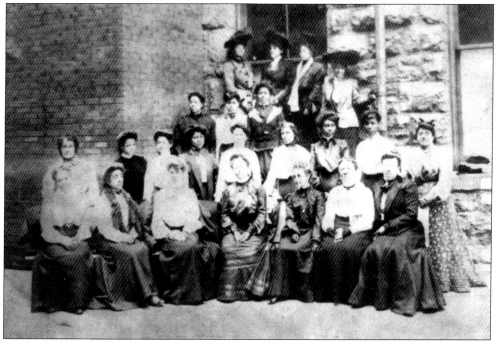

In 1877, black teachers were employed to teach in the black schools. The Colored Educational Council had petitioned the board explaining that black teachers were better equipped, and it was more desirable that black teachers should teach black students because they were free from unfavorable social surroundings that breed prejudice. Many also felt that black teachers would serve as role models. (Photograph courtesy of John A. Wright.)

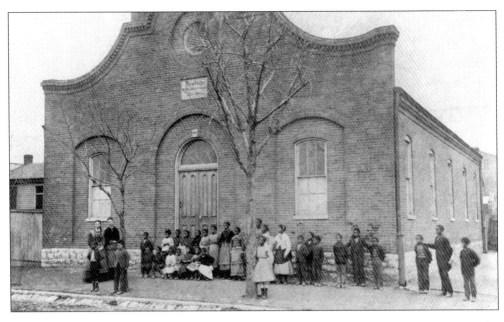

Except for Sumner High School, the "colored schools" were assigned numbers. In 1878, the Colored Education Association requested that their schools be named for "prominent negroes." The association suggested such names as Alexandre Dumas, Crispus Attucks, and Toussaint L'Ouverture. The board countered with the offer to name the schools after "white men who have distinguished themselves in the cause of the colored race." After having their proposal rejected, the board finally approved naming the schools after "distinguished negroes" as suggested by the Colored Education Association. The top photo shows Banneker Elementary School (Colored School No. 5). Some of its pupils are pictured in the bottom photo. (Bottom photograph courtesy of St. Louis Public Library and top photograph courtesy of the Western Manuscript Collection, University of Missouri-St. Louis.)

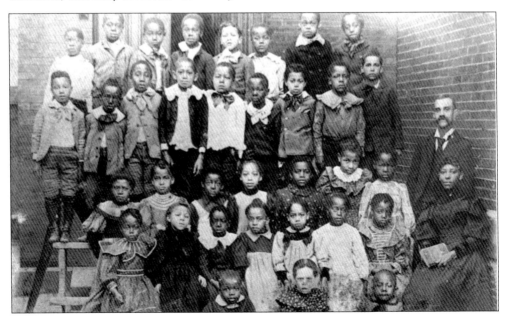

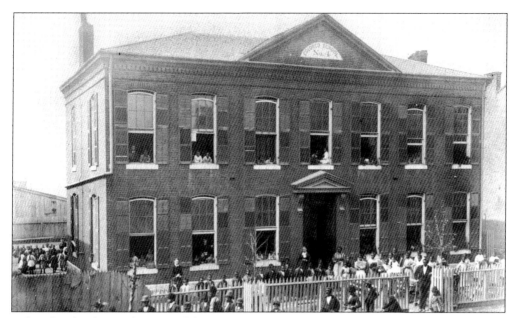

Colored School No. 4, pictured here at Cozens Street near Pratt Avenue (now Jefferson Avenue), was later renamed L'Ouverture Elementary School for Pierre Dominique Toussaint L'Ouverture, a Haitian patriot who led a 1791 revolt against the French and paved the way for the Louisiana Purchase and St. Louis being a part of the United States. (Photograph courtesy of the St. Louis Public Library.)

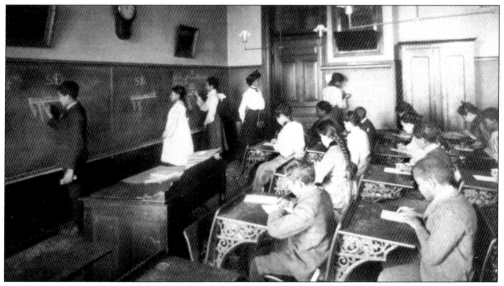

Some L'Ouverture students are pictured here engaged in a grammar lesson with their black instructor. In 1877-78, the first year of black instructors in the St. Louis Public Schools, the number of black students attending school rose by 35 percent. In the second year enrollment increased by another 20 percent and in the third year by another 27 percent. Superintendent William Torrey Harris explained this increase by stating large numbers of blacks had kept their children out of public schools because they felt the white teachers were "hostile." (Photograph courtesy of the Western Manuscript Collection, University of Missouri–St. Louis.)

Dumas Elementary School, formerly Colored School No. 1, was one of five schools for African American children with a total attendance of 1600 pupils that existed in St. Louis at the end of the Civil War. Colored School No. 1 opened first at Fifth and Gratiot. It later moved from a number of rented quarters to Lucas Avenue and Fourteenth Street in 1878. It closed in the early 1970s. The school was named for Alexandre Dumas, author of several books including, *The Count of Monte Cristo*. (Photograph courtesy of the St. Louis Public School Archives.)

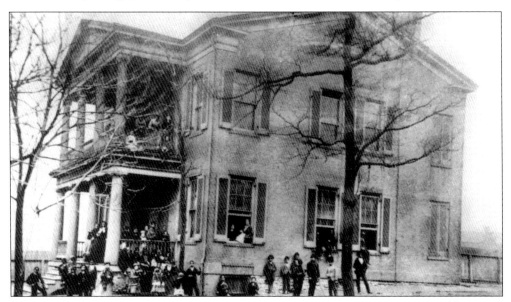

Dessalines Elementary School, originally called Colored School No. 2, opened in 1866 at Tenth and Chambers Streets. In 1871, the school moved to North Twelfth and Webster Streets. The school was named for General Jean-Jacques Dessalines, an aide to Pierre Dominique Toussaint L'Ouverture, father of the Haitian Revolution. He took control of the Haitian army after Toussaint L'Ouverture's death and helped to establish the second republic in the Western Hemisphere. (Photograph courtesy of the St. Louis Public Schools.)

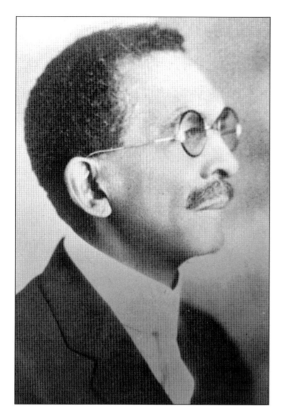

In the early history of Washington University, it accepted African American applicants, but stopped doing so shortly before moving to its present location. Walter Farmer, pictured here, graduated with honors from the university's Law School in 1887. Farmer was the attorney for Harrison Duncan, an African American who was mistakenly hung in Clayton, Missouri for the murder of James Brady, a police officer. The hanging led to the Brady-Duncan folk tale and protest song. Other known black graduates were: from the Law School, Hale Parker, 1891; Eli Hamilton Taylor, 1893; Critten Clark, 1896; from the Manual Training School, August O. Thornton, 1893; Eugene Hutt, 1892; and Rufus Stokes, 1893; and from the Academic School, Reverend W. H. Roberts, 1896. (Photograph courtesy of Washington University Archives.)

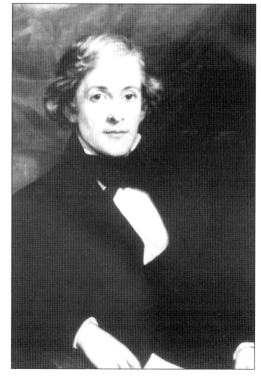

William Greenleaf Eliot, pictured here, was one of the founders of Washington University. He is credited with the founding of the St. Louis Public School system, Mary Institute, the now closed Smith Academy, and the Manual Training School. He played a major role in Washington University, opening its doors to blacks in the school's early history. Eliot opposed slavery and preached in favor of prohibition and women's suffrage. He declared publicly that he would never return a fugitive slave to his or her master. Eliot assisted and protected Archer Alexander, an escaped slave, who later modeled for Freedom's Memorial Statue in Washington, D.C. (Photograph courtesy of Washington University Archives.)

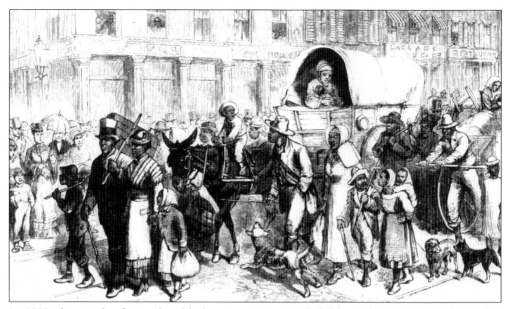

In 1879, thousands of penniless black men, women, and children—known as "Exodusters"—passed through St. Louis on their way to Kansas and other midwestern and western states in search of a better life. As the migrants began to arrive in the city by boat, Charlton H. Tandy assembled African Americans on March 17 at the St. Paul African Methodist Episcopal Church to arrange for their temporary relief. (Drawing from April 19, 1879 issue of *Frank Leslie's Illustrated Newspaper*, courtesy of John A. Wright.)

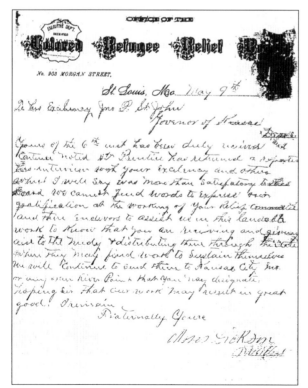

The Reverend Moses Dickson, head of the Colored Refugee Board, with offices at 903 Morgan Street, wrote this letter to the governor of Kansas thanking him for his assistance with the refugees. Prominent African Americans in St. Louis organized, fed, housed, and supplied transportation for the impoverished immigrants when they reached the city. The refugees had come from southern states where they had suffered harsh political, social, and economic oppression at the hands of their former slave masters once Reconstruction had ended, and the last federal troops had been withdrawn. (Letter courtesy of James Vincent.)

Captain Charlton H. Tandy led the movement to end segregation of public streetcars and the fight for public education for blacks. During the 1880s, he worked to enforce an 1867 court order allowing blacks to ride inside public transportation vehicles. He would grab the reins and hold the horses until passengers—black and white alike—were allowed to board. Tandy became a leader in the movement for public education for blacks. He worked with James Milton Turner to raise money for Lincoln Institute (now Lincoln University). (Photograph by Nathan Young, courtesy of St. Louis University.)

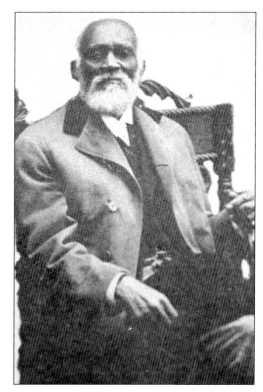

IN THE

Supreme Court of Missouri.

DIVISION No. 1.

OCTOBER TERM, 1902.

CHARLTON H. TANDY,
 (Plaintiff) Respondent,

vs. } No. 10,746.

ST. LOUIS TRANSIT COMPANY,
 (Defendant) Appellant.

APPEAL FROM THE CIRCUIT COURT OF THE CITY OF ST. LOUIS, COURT ROOM No. 5, HON. D. D. FISHER, JUDGE.

Statement and Brief for Appellant.

STATEMENT.

The petition in this case was filed in the Circuit Court on October 27, 1900, and was in substance as follows:

That on or about the 10th day of August, 1900, Annie E. Tandy, lawful wife of the plaintiff, was a passenger on a Page Avenue car owned and operated by the defendant corporation. That "while she was in the act of alighting from said car, after it had stopped on the west side of Walton avenue, at its intersection

Charlton H. Tandy passed the Missouri state bar examination and established a law practice in St. Louis in 1894. Tandy went before the Missouri Supreme Court in 1902 when one of the St. Louis Transit Company's transit cars pulled off before his wife Annie E. Tandy could disembark, causing her to break two ribs and have bruises and wounds. Tandy sued the transit company for $2,500, but received only $600. He filed for a new trial but it was overruled. (Document courtesy of John A. Wright.)

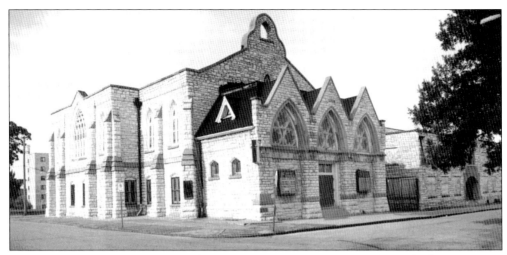

Because of segregation blacks were forced to establish their own churches. The first Protestant congregation for African Americans was First African Baptist Church (now known as First Baptist Church) located at Third and Market. The church grew out of Sunday school and religious services for whites, organized in 1818 by two Baptist missionaries. In 1822, African American worshippers formed a separate branch of the church. The church first operated under the direction of Reverend John Mason Peck with the assistance of John Berry Meachum. After Meachum became ordained in 1825, he founded the church and became its first pastor. (Photograph of present church at Cardinal and Bell Avenues by John A. Wright.)

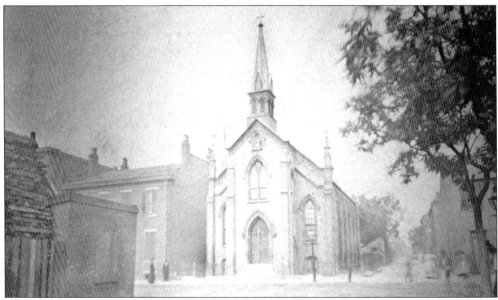

Although Roman Catholic parishes in St. Louis were never officially segregated, African Americans often were excluded from white congregations. In the early years of the city, many black Catholics gathered for Sunday mass in a chapel of St. Francis Xavier Church. In the 1870s, Bishop Ryan organized St. Elizabeth's Parish as a citywide parish for African Americans. The refurbished Vinegar Hill Hall at Fourteenth and Gay Streets was dedicated as St. Elizabeth's Church on May 18, 1873. In 1912, the church moved to this location at 2721 Pine Street. (Photograph courtesy of the Midwest Regional Jesuit Archives.)

Four

SEPARATE AND UNEQUAL

At the turn of the century, there were slightly more than 35,000 blacks living in St. Louis. The city ranked second only to Baltimore among major American cities in the percentage of blacks in the population. Although blacks were free to live in many parts of the city, more than one-half lived in the Central City and Mill Creek Valley areas. Despite the fact that blacks lived and worked throughout the city, they were denied many of the privileges given to white citizens and forced to work in low paying jobs. They were also denied admission to white theatres, churches, restaurants, hotels, recreational facilities, hospitals, social clubs, and even cemeteries. Thus segregated by custom and by law, blacks created their own churches, staffed their own schools, and organized professional trade and social organizations to serve the needs of their community.

Black citizens played a major role in the daily life of the city. Although confined to low level jobs many were able to provide for their families by working in jobs maintaining the streets, driving dray wagons, waiting on tables in restaurants and hotels, working in warehouses, taking care of children, and washing and cleaning homes for white citizens. (Photograph of Market and Chesnut Streets looking west from 12th Street around 1900 courtesy of the Mercantile Library.)

In 1913, a committee was formed to find ways to contain the growth of the black population. The committee's report made reference to major areas of black concentration and stated that black growth appeared natural and that the only way whites could contain its movement was through legal segregation. To gain support of the white community the committee promoted their cause with the showing of the movie "Birth of a Nation" at the Olympic Theater, 107 South Broadway in 1915. (Document courtesy of the St. Louis Public Library.)

In 1916, the citizens of St. Louis went to the polls to cast their ballots on an ordinance to legally segregate black and white residents. The ordinance passed by more than a 2-1 majority although many black and white citizens opposed it. When the Supreme Court later ruled that the ordinance was unconstitutional, white citizens escalated the use of race restrictive covenants to prohibit white property owners from selling to minorities. (Flyer courtesy of Elijah P. Lovejoy Society.)

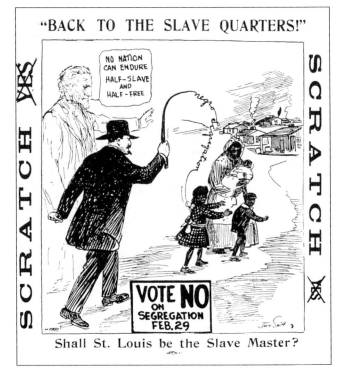

In 1900, the American Book and Bible House at 209-213 North Seventh Street published *The Negro A Beast or In the Image of God,* by Charles Carroll, which went to great length to show African Americans were not human. Pictured here is the beginning of Chapter IV, which discusses brain weight. (Photograph courtesy of the St. Louis Public Library.)

Chapter IV.

Convincing Biblical and Scientific Evidence that the Negro is not of the Human Family.

The following measurements of brain weights collected by Sanford B. Hunt, in the Federal army during the late war in the United States, demonstrates that the White blood is the lever which elevates; and that the Negro blood is the lever which lowers the mental grade of individuals, tribes, nations, continents, and the world at large.

<table>
<tr><td></td><td></td><td>Weight of brain
(Gramines.)</td></tr>
<tr><td>24</td><td>Whites</td><td>1424</td></tr>
<tr><td>25</td><td>Three parts white.....................</td><td>1390</td></tr>
<tr><td>47</td><td>Half-white, or mulattoes................</td><td>1334</td></tr>
<tr><td>51</td><td>One-quarter white....................</td><td>1319</td></tr>
<tr><td>95</td><td>One-eighth white.....................</td><td>1308</td></tr>
<tr><td>22</td><td>A sixteenth white....................</td><td>1280</td></tr>
<tr><td>141</td><td>Pure negroes.........................</td><td>1331"</td></tr>
</table>

[*Topinard's Anthropology,* p. 312.]
(208)

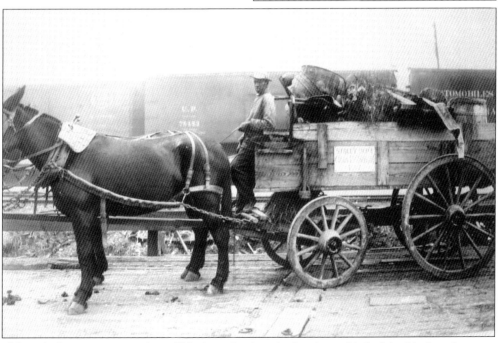

Although there were a number of black professions in the city, a third of the black males were confined to unskilled labor positions. According to the 1900 federal census, 10 percent of black male workers were draymen, hackmen, or teamsters. (Photograph courtesy of the St. Louis Public Library.)

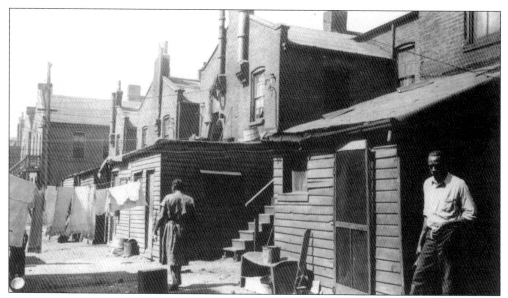

Although blacks hoped for a better life, many were confined to segregated areas like the one pictured above in the Carr Square Village section of the city prior to the 1940s. Segregation and discrimination was a way of life in St. Louis at the turn of the century. (Photograph courtesy of the Missouri Historical Society.)

The southeast corner of Jefferson and Lawton Avenues, pictured here, was in the heart of the African American community's business and entertainment district. The Deluxe Recreation Parlor seen on the left side of this picture was owned by Jesse Johnson, a theatrical agent. (Photograph courtesy of the Missouri Historical Society.)

Scott Joplin, one of St. Louis' well-known downtown residents, lived in St. Louis from 1885–1894, and again from 1900–1906. While in St. Louis, he composed "The Entertainer," "Gladiolus Rag," and "Treemonisha," an ambitious opera based on folk-music themes. During his time in St. Louis, he also changed careers from an itinerant piano player to a composer and teacher. Joplin took part in the 1904 World's Fair and played "The Cascades," which he had composed in honor of the fair. (Photograph courtesy of Billye Crumpton.)

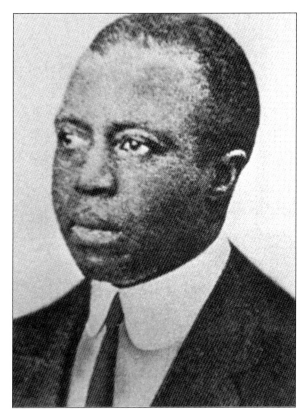

While in St. Louis, Scott Joplin, between 1901 and 1903, lived in this four family flat (left) with his wife Belle Hayden Joplin. His home was designated a national historic landmark in 1976 and rescued from demolition by Jeff-Vander-Lou, a neighborhood development corporation. All Joplin's other residences in St. Louis, as well as places where he worked, have been destroyed. (Photograph by John A. Wright.)

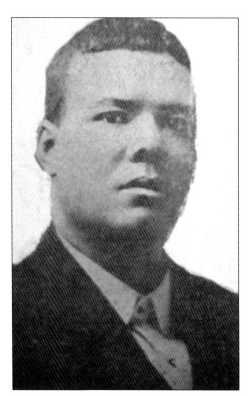

The father of the blues and jazz was Tom Turpin of St. Louis. Turpin owned the Rose Bud Bar at 2220-22 Market Street. In 1904, the Rosebud Café sponsored its third annual ball and piano contest in Douglass Hall. An account published in *The Palladium* newspaper reported, "It was one of the largest, finest and best conducted affairs of the kind ever held in St Louis. The Hall was packed and jammed [with] many well-dressed, good looking and orderly people from all classes of society…Mr. Tom Turpin presented an elegant gold medal to the successful contestant…." (Photograph by Nathan Young, courtesy of St. Louis University Archives.)

Tom Turpin published the "Harlem Rag" in 1896. Other compositions of his include "Bowery Buck," "St. Louis Rag," "The Buffalo," "Nannette Waltz," and his last during the World War entitled "When Sambo Goes to France." Most of the music Turpin submitted, the publishers in New York declared it was too difficult for the average player, and several of them refused to publish the then strange pieces. (Sheet music courtesy of Billye Crumpton.)

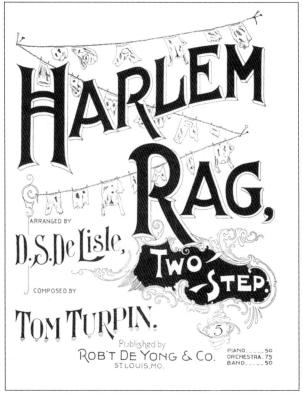

In 1910, Charles Turpin, the brother of Tom Turpin, ran for constable and won, becoming the first black to be elected to public office in Missouri. From that time until his death in 1935, he was a dominant figure in Republican politics in St. Louis. When he died in 1935, he was Justice of the Peace serving a second term in the only district that withstood the New Deal landslide. (Photograph by Nathan Young, Courtesy of the Western Manuscript Collection, University of Missouri-St. Louis.)

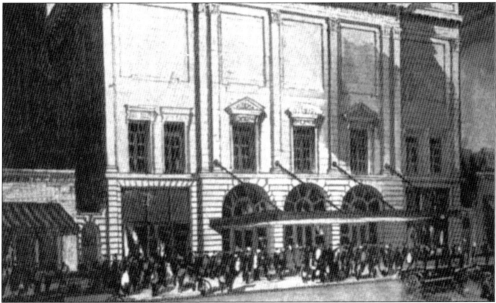

The Booker T. Washington Theatre at 2248 Market Street was one of Charles Turpin's business ventures. His show business started out under a crude tent on Market Street, which was so successful he built and christened the Booker T. Washington Theatre, which operated from 1912 to 1930. The theatre had a seating capacity of 1000 and featured vaudeville and other live entertainment, as well as motion pictures. Because the theatre was part of the Theatre Owners' Booking Association, the black vaudeville circuit, the theater featured appearances by such black stars as Ethel Waters, Bessie Smith, and Ma Rainey. (Photograph courtesy of John A. Wright.)

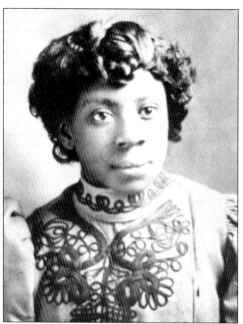

St. Louis is the home of many folk tales and ballads. The ballad of Frankie and Johnny is said to be based on a murder that took place on October 15, 1899, in a St. Louis lodging house located at 212 Targee Street. Newspaper accounts from the time report 22-year old Frankie Baker, pictured here, killed two-timing "Johnny," 17-year-old Albert Britt. Some versions say he was stabbed to death, while others say he was shot. On the night of the incident, Bill Dooley, a black pianist and songwriter, composed the song that was first known as "Frankie and Albert." (Photograph courtesy of the Mercantile Library.)

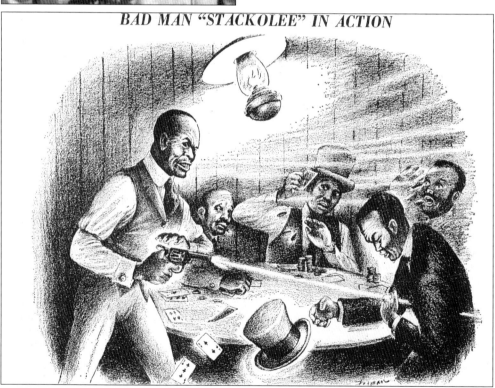

BAD MAN "STACKOLEE" IN ACTION

Another folk ballad out of St. Louis is the "Ballad of Stackalee." The song originated in St. Louis after an incident in Bill Curtis' saloon at Eleventh and Morgan Streets on Christmas night in 1895. Billy Lyons grabbed the "lucky" hat of Lee Shelton (known as "Stack Lee" because he had once been a stoker on the riverboat Stacker Lee), who was at the gambling table. Shelton then pulled out his 44 revolver and shot Lyons to death. (Drawing courtesy of the *St. Louis American Newspaper*.)

The Ballad of Brady-Duncan is said to be one of the early protest songs regarding police brutality and civil rights. This folk ballad grew out of an incident that occurred on October 6, 1890, in a saloon owned and operated by an African American named Charles Stark at 715 North Eleventh Street. Police had come to the saloon to break up a crowd gathering out front. A fight broke out, and a police officer by the name of James Brady was shot and killed. William Harrison, pictured here, was arrested for the murder and hung. During the trial and after the hanging, tension between the races ran high in the city. Charles Stark admitted to the killing after Harrison had been hung. (Drawing courtesy of Greta Wilkinson.)

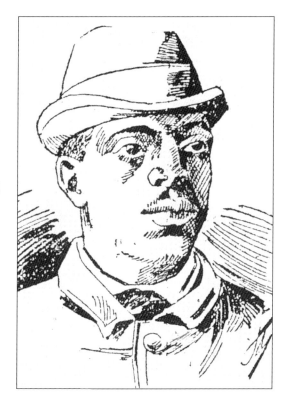

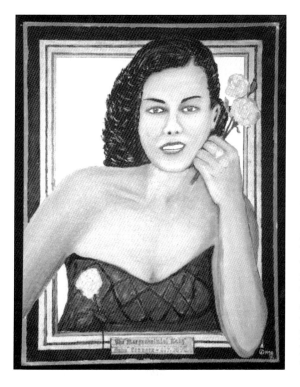

One of the legends of downtown St. Louis was Sarah Bilas Conners, better known as Babe Conners, who owned and operated the Castle Club at 210 South Sixth Street. The club was known to most all the adult males of St. Louis. A U.S. double eagle (a gold $20 piece) was required for passage into the club. Conners maintained eight to ten beautiful "Creole" maidens from Louisiana for her guests' entertainment. Two well known songs that came out of the club were "There'll be a Hot Time in the Old Town Tonight" and May Irwin's "Bully Song." (Painting by Nathan Young, courtesy of St. Louis University Archives.)

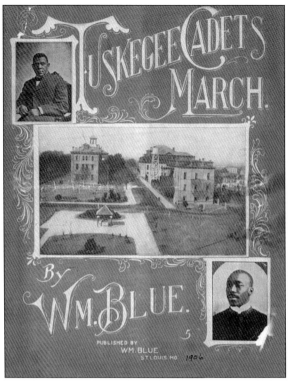

Professor William Blue was a pioneer musical composer and band organizer. He traveled with Billy Kersand's Minstrel and with Ernest Hogan as a cornet player. Blue organized the Sunday band concerts at the Douglass and Pythian Halls and gave promising young singers and musicians a chance to perform at the programs. He composed the Tuskegee Cadets March in 1906 and organized the Shrine Band of 50 pieces here in St. Louis. Blue is shown here with one of his early bands. (Photographs courtesy of John A. Wright.)

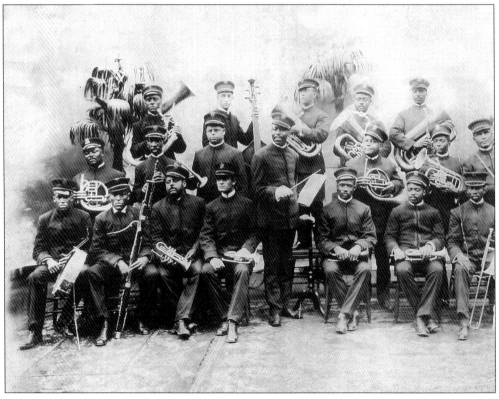

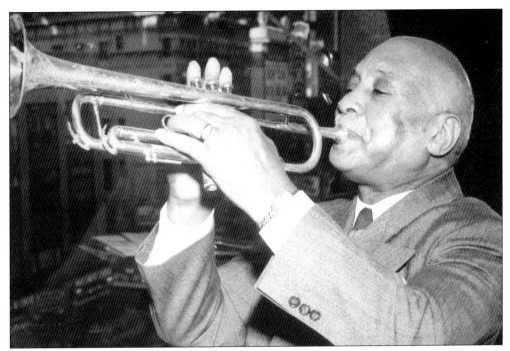

W.C. Handy arrived in St. Louis from Chicago by boxcar to seek his fortune. The lonely, hungry nights on the cobblestone levee taught him the sights and sounds of the river front. He stored them in his brain, and years later he brought world fame to the city and himself with the "St. Louis Blues." All told, the song brought Handy nearly $1,500 in royalties. Thanks to W.C. Handy's genius, there is hardly a spot on the face of the globe where the city's name has not been sung to his melody. (Photograph courtesy of the Mercantile Library.)

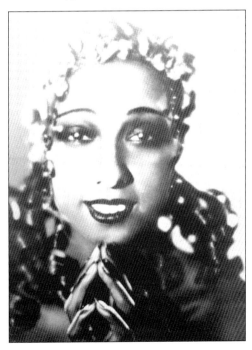

Josephine Baker, born Freda Josephine McDonald, lived on Gratiot Street near Targee Street. After attending Lincoln Elementary School, she began performing for pennies outside the Booker T. Washington Theatre and gradually became a member of her family's vaudeville act. She eventually left St. Louis and became famous in Paris as the lead exotic dancer in "Les Folies Bergere." When she returned to St. Louis in 1951, she refused an offer of $12,000 a week to perform at the Chase Hotel because the hotel would not allow integrated audiences. She later appeared free at a rally at the Kiel Auditorium in 1952. (Photograph courtesy of the Mercantile Library.)

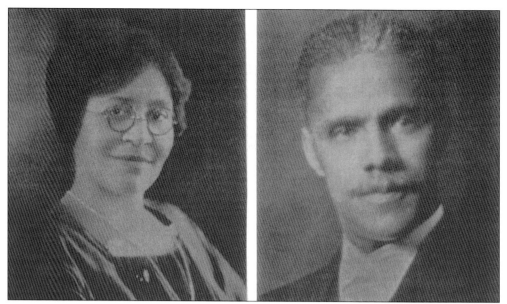

Poro College at 2223 Market Street, operated by Annie Malone, was one of the many black businesses in downtown St. Louis. Ms. Malone was a humanitarian and a great philanthropist who helped thousands. She was born in poverty and became a millionaire by bucking the odds and developing a hair and cosmetic business. The first black fire company in St. Louis came about under Mayor Henry Kiel at the request of Ms. Malone's husband, Aaron E. Malone, pictured on the right. (Photograph of Annie Malone courtesy of John Wright and the photograph of Aaron Malone courtesy of the Western Manuscript Collection, University of Missouri-St. Louis.)

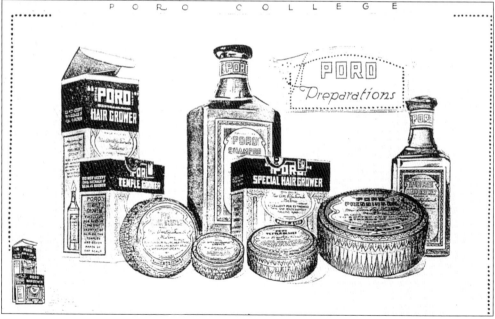

Shown here are some of the products produced at Poro College. The Poro system achieved renown not only in the United States, but internationally in the Caribbean, Africa, and the Philippines. (Advertisement courtesy of Olivia Blackmore.)

Madame C.J. Walker was a pioneer in the hair care business who got her start with Annie Malone. She was born to a former slaves in Louisiana. She moved to St. Louis in 1887 and remained for 18 years working as a washerwoman for $1.50 a day. For part of her time in St. Louis, she lived at 1615 Linden Street. During this period, her hair began to fall out. She tried a variety of methods without success. Then one night, she had a dream showing her how to develop a mixture. She tried it, and it worked and she went on to market it. As a result she became a millionaire with shops all over the country. (Photograph from the Walker Collection of A'Lelia Bundles, Courtesy of the Black World History Museum.)

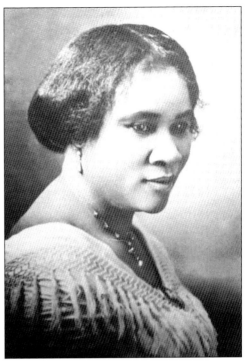

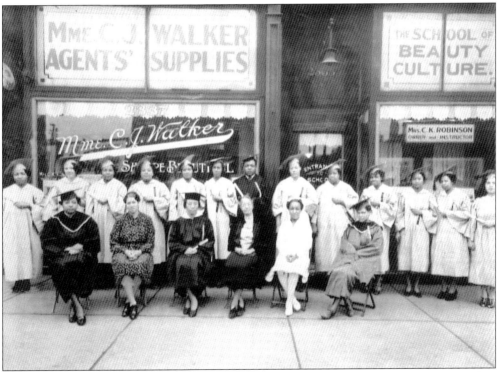

Pictured here are some of the graduates of Madame C.J. Walker's beauty school, located in the 2300 block of Market Street. (Photograph from the Walker Collection of A'Lelia Bundles, Courtesy of the Black World History Museum.)

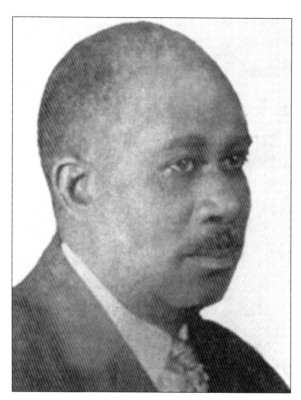

Joseph Mitchell, pictured here, founded the *St. Louis Argus* around 1912, with the assistance of his brother William Mitchell and William's wife, Nannie Mitchell. With Joseph Mitchell as managing editor, the newspaper championed better schools, educational opportunities, and full civil rights for blacks. It is the oldest black newspaper in Missouri and one of the oldest in the United States. The name "Argus" refers to a creature in Greek mythology that had 100 eyes and never slept. (Photograph by Nathan Young, courtesy of St. Louis University Arch.)

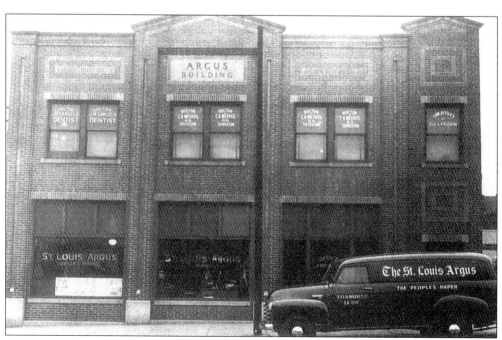

Before moving to its present location at 4595 Dr. Martin Luther King Drive, the Argus operated out of this plant at 2312-14-16 Market Street. (Photograph Courtesy of St. Louis Public Schools.)

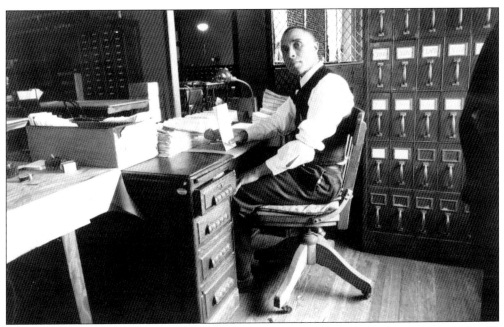

In 1928, a young lawyer by the name of Nathan Young used his legal experience to officially incorporate St. Louis' second black newspaper and signed on as editor. The *St. Louis American's* first issue on March 17, 1928 sold out of its 2,000 copies with the headline, "Pullman Porters May Strike." Since its first edition, the paper has aligned itself with the struggle for equal rights for black citizens and diligently covered the political and civil rights issues of the day. (Photograph courtesy of St. Louis University Archives.)

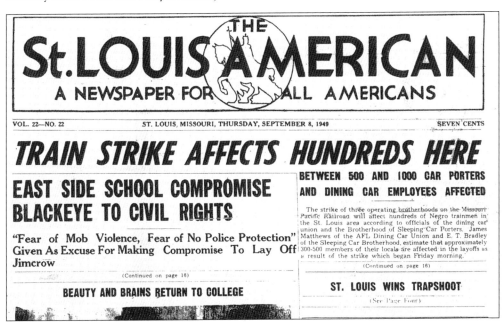

A September 8, 1949 issue of the *St. Louis American* is pictured here with news of a train strike, which would affect hundreds of blacks in the St. Louis area. (Copy courtesy of the St. Louis Public Library.)

In 1911, several women who were members of the Union Memorial African Methodist Episcopal Church met at the home of Ada Chapman to discuss the need for a Young Women's Christian Association movement for black girls. With the sanction of the St. Louis YWCA, the Chapman Branch was formed. On April 13, 1912, the branch was renamed for Phyllis Wheatley, a black poet born in Africa and brought to Boston as a slave. The Wheatley Branch was located in this renovated mansion at 709 North Garrison Avenue. It moved to the Locust Street location in 1941. (Photograph courtesy of the Mercantile Library.)

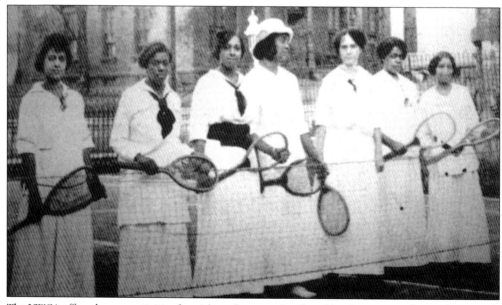

The YWCA offered many activities for girls such as tennis, played by these tennis fans. (Photograph courtesy of the Western Manuscript Collection, University of Missouri-St. Louis.)

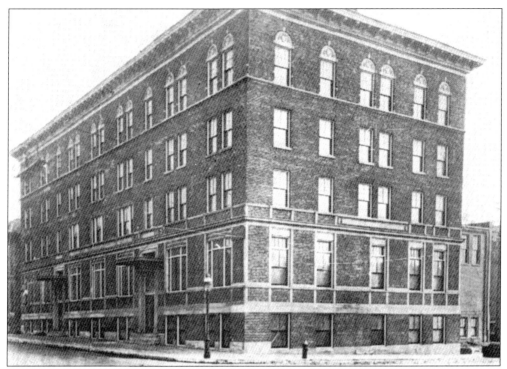

The Pine Street YMCA for African American Men, pictured here, was dedicated on March 23, 1919. Before it was completed, it was used for housing and feeding black troops on local stopovers during the last days of World War I. The YMCA was organized under the leadership of John Boyer Vashon, principal of Colored School No. 10 in 1887. It was first called the YMCA for Colored Men. It became a branch of the Metropolitan St. Louis YMCA in 1912. (Photograph courtesy of John A. Wright.)

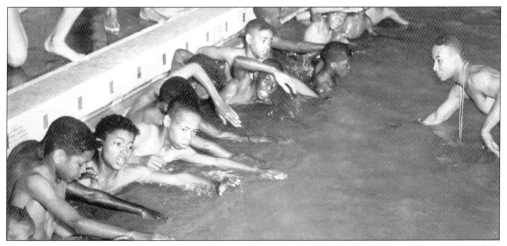

The Pine Street YMCA, which advertised itself as "the social center of St. Louis," provided well-appointed facilities that included a swimming pool, a gymnasium, meeting rooms, dormitories, and a cafeteria. Leading black businessmen served on the board of directors, and many nationally known black lecturers spoke there. It was demolished in 1960. (Photograph courtesy of the Mercantile Library.)

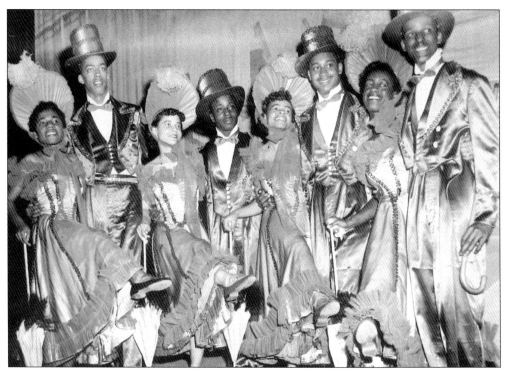

One of the major activities of the Pine Street YMCA was the "Y Circus" during the 1940s. Each year, the "Y" would sponsor programs with acts from young people like these in the picture, along with nationally known artists such as Nat King Cole. (Photograph courtesy of Mercantile Library.)

A great deal of the revenue from the Pine Street "Y Circus" was used to help fund summer camp and activities for the boys and girls at Camp River Cliff in Bourbon, Missouri. (Photograph courtesy of the Western Manuscript Collection, University of Missouri-St. Louis.)

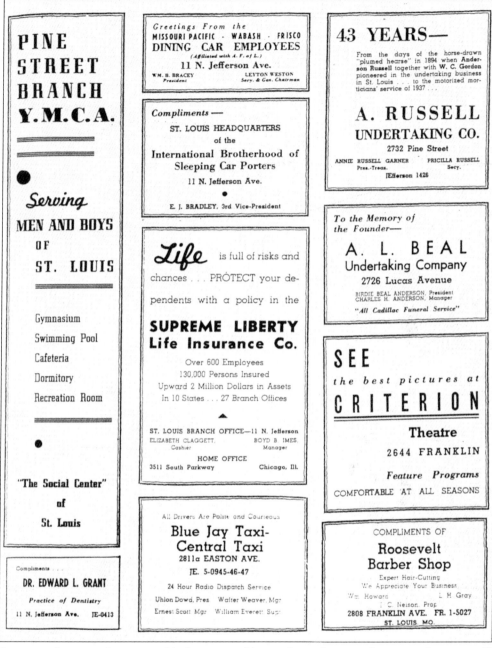

Because of segregation, many black communities such as the one downtown became self-contained. Residents could find most services without leaving the area. This advertisement represents a small sampling of some of the services offered by black businesses in the downtown area. (Advertisement courtesy of St. Louis University Archives.)

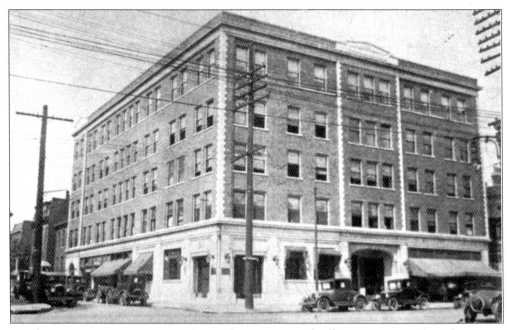

People's Finance Corporation, on the northwest corner of Jefferson Avenue and Market Street, was constructed by black workers in the hub of the black business and residential district. The first floor of the building contained a bank (the first one owned by blacks), a drug store, and offices. Doctors, lawyers, *The St. Louis American,* newspaper, a pharmacy, and commercial groups were also tenants of the building. Because of the Great Depression, the building ended up with white ownership. (Photograph courtesy of Julia Davis.)

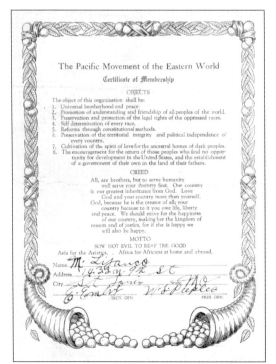

The Pacific Movement of the Eastern World (PMEW), a pro-Japan organization, used the People's Finance Corporation as one of its meeting places. It is estimated that several thousand St. Louis African Americans joined the movement because of their desire for full societal equality, whether achieved within or outside the borders of the United States. In addition to embracing a "back to Africa" orientation, PMEW and its emigration policies also endorsed colonization projects in Japan and Brazil. (Document courtesy of Washington University Archives.)

The Knights of Pythias, a secret fraternal organization headquartered at 3137 Pine Boulevard, provided for the care and burial of its members and their families. It also provided assistance to members desiring to purchase a home. The organization was founded in 1886 and became active in St. Louis in 1870. (Document courtesy of Central Baptist Church.)

The Ancient United Knights and Daughters of Africa, another fraternal group, was located on the northwest corner of Lucas and Compton Avenues. Like the Knights of Pythias the organization provided for the welfare of its members. (Document courtesy of Central Baptist Church.)

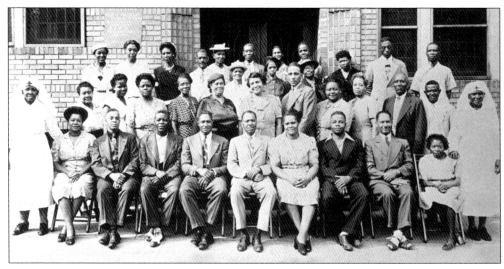

Individuals in this picture are members of the Universal Negro Improvement Association founded by Marcus Garvey in front of the Jackson Funeral Home at 2649 Delmar Boulevard. The organization came to the United States in 1916, and its national membership soon grew to about 2,000,000. It established a chain of cooperative grocery stores, restaurants, steam laundries, tailoring and dressmaking shops, millinery stores, and a publishing house to meet the needs of the black community. (Courtesy of John A. Wright.)

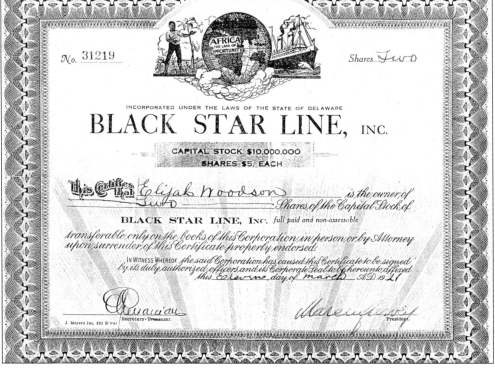

An aim of the Universal Negro Improvement Association was to establish a black nation in Africa. Pictured here is one of its shares in the short-lived steamship firm, the Black Star Line. (Document courtesy of John A. Wright.)

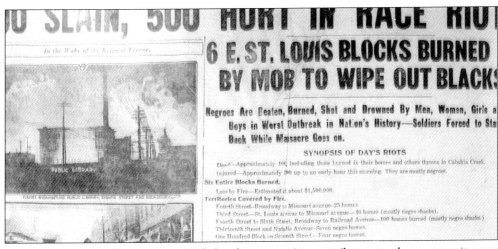

The Urban League of St. Louis, which has been a major contributor to the community, was organized in reaction to the East St. Louis race riots of 1917. Those riots began when white East St. Louisians attacked black workers and immigrants who had migrated to the predominantly white city seeking jobs. When the riot ended, 39 blacks and nine whites had been killed. Since St. Louis the year before had passed a segregation ordinance, a group of citizens decided to act and formed the Urban League. (Photograph courtesy of the St. Louis Metropolitan Urban League.) *Also NAACP part*

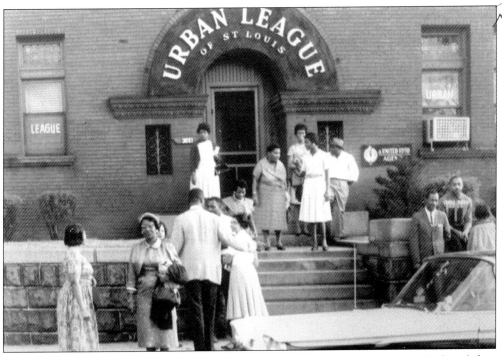

Since its beginning, the interracial Urban League, comprised of citizens, has worked to defuse racial tension by organizing to alleviate some of the awful conditions black St. Louisians have faced in their daily lives. At the time the League was formed, blacks were segregated, poor, had the lowest and worst lowest-paying jobs and attended the oldest, most-crowded schools. They also had the highest poverty, sick, and death rates. (Photograph courtesy of the St. Louis Metropolitan Urban League.)

Until the Urban League organized successful recreational programs on vacant lots for black children, city officials neglected to provide them. However, because of the success of the Urban League's program, the St. Louis Board of Education opened several segregated playgrounds for black children. (Photograph courtesy of the Missouri Historical Society.)

Although blacks were left out of the prosperity of the "Roaring 20s," they were held back even more with the stock market crash of 1929. Few of these job seekers found work. In 1936, the Urban League staff could place only 10 percent of the 22,000 African Americans who filed employment applications. (Photograph courtesy of the Metropolitan Urban League.)

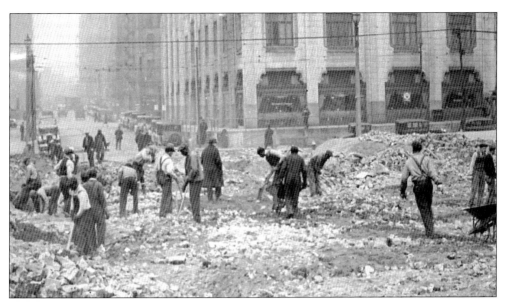

The devastating 1927 tornado wreaked havoc on parts of the black St. Louis community as it headed toward the downtown corridor, which included the Mill Creek area where many blacks lived. Not only did blacks in the areas get hit by the tornado, they suffered physical devastation, and they were reminded of their second-class status when clean-up and reconstruction began. At first, they were virtually excluded from rebuilding activities and when included, were provided lower-quality relief. (Photograph courtesy of the St. Louis Public Library.)

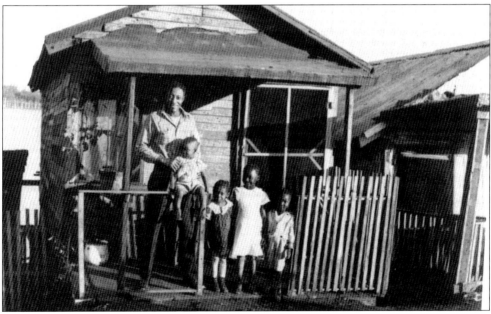

From 1929 to 1936, during the Great Depression, St. Louis had the nation's largest "Hooverville," a shantytown derisively named for President Herbert Hoover. In 1933, an estimated 5000 destitute men, women, and children were living in this squatter colony that stretched for miles along the Mississippi River. This settlement was one of the few racially integrated areas of the city. (Photograph courtesy of the Western Manuscript Collection, University of Missouri-St. Louis.)

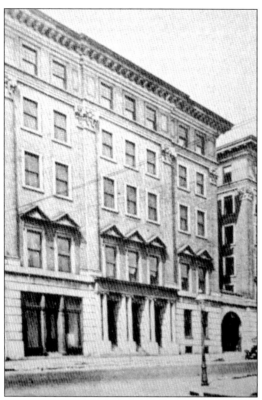

In 1919, City Hospital No. 2, a 177-bed facility, opened at 2945 Lawton Place. A committee of 17 black physicians led by Christopher K. Robinson, owner of a printing company and publisher of *The Clarion* newspaper, convinced city officials to purchase the vacant Barnes Medical College as a health-care center for black city residents and doctors. When the facility opened, it was one of five institutions in the United States that offered hospital training to black physicians. (Photograph courtesy of Jacqueline Ervin Creighton and Ella Brown.)

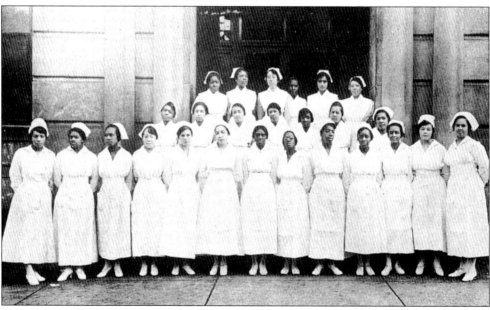

The City Hospital No. 2's School of Nursing was accredited in 1920. Pictured here are members of the 1922 student body and staff. Estella Massey Riddle Osborne, a member of the second class, went on to become superintendent of the Homer G. Phillips Hospital School of Nursing, a teacher at New York University, and president of the National Association of Colored Graduate Nurses. (Photograph courtesy of Jacqueline Ervin Creighton and Ella Brown.)

This dwelling at Lawton and Pine Streets served as a residence for the City Hospital No. 2 nurses. (Photograph courtesy of Jacqueline Ervin Creighton and Ella Brown.)

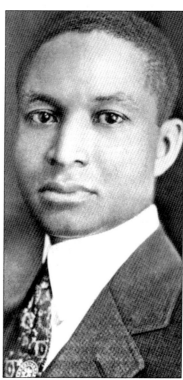

City Hospital No. 2 and Training School for Nurses were born out of a dire need for adequate medical facilities for the care of African American patients and training of African American nurses and doctors. However, three years following its opening, it became evident that the hospital was quite inadequate. Through the efforts of Attorney Homer G. Phillips, a bond issue was passed in 1923 by the citizens of St. Louis with the understanding some funds would be used to construct a new hospital for African Americans. However because of opposition, the hospital was not begun until 1932. Phillips did not live to see his dream come true. He was shot to death while waiting for a bus in a never-solved murder. (Photograph by Nathan Young, courtesy of the Western Manuscript Collection, University of Missouri-St. Louis.)

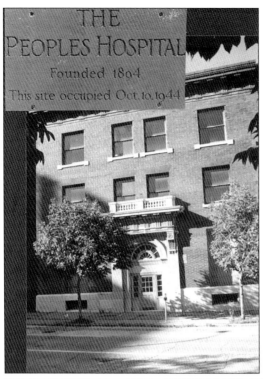

In 1894, Provident Hospital at 3447-49 Pine Street was incorporated as a private hospital. In 1918, it was renamed People's Hospital. It later moved to the site pictured here at 2221 Locust Street. For many years it was the only place black physicians and surgeons could treat private patients. In 1898, the hospital established a nurse's training program for black women. (Photograph by John A. Wright.)

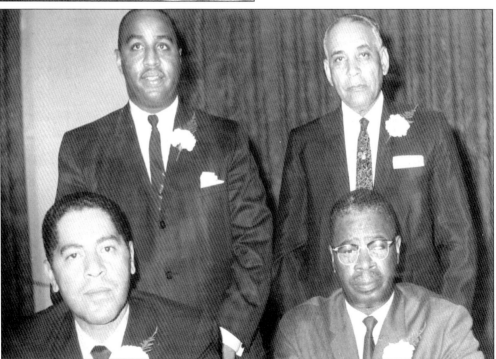

Pictured here are members of the hospital's expansion exploratory team with the hospital's director, Morris Henderson, standing on the left. At the peak of the hospital's operation, it was a 75-bed, short term general hospital. It closed in 1978. (Photograph courtesy of the Mercantile Library.)

In 1933, the Sisters of St. Mary opened their previously all-white hospital, founded in 1877, to a group of black physicians; at the same time they admitted African American patients. One of the goals of St. Mary's Infirmary was to relieve the over crowded condition of City Hospital No. 2, which had a bed capacity of 205 and was handling over 500 patients. From the time the hospital opened until the opening of Homer G. Phillips Hospital in June 1937, the institution cared for several thousand of city patients. The hospital closed in 1966. (Photograph courtesy of Frank Richards.)

Pictured here are some of the members of St. Mary's Infirmary medical staff. (Photograph courtesy the Sisters of Franciscans.)

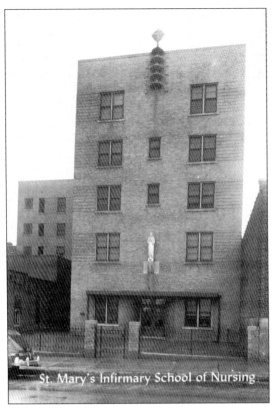

On October 7, 1933, St. Mary's Infirmary School of Nursing, which previously existed for the education of the religious of the Order, admitted the first class of African American students under the organization and direction of Sister Mary DeChantal, S.S.M. The school offered the basic professional three-year program leading to the diploma of graduate nurse and had the distinction of being the first Catholic School of Nursing organized for African Americans in the United States. (Photograph courtesy of the Sisters of Franciscans.)

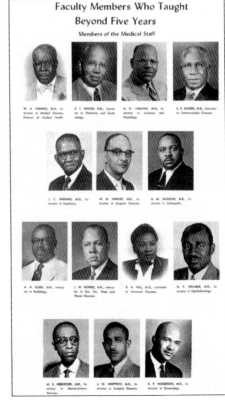

Pictured here are St. Mary's Infirmary School of Nursing faculty members who had taught beyond five years when the school closed in 1958. (Photograph courtesy of the Sisters of Franciscans.)

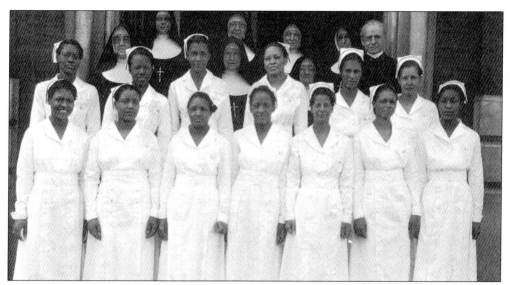

These young ladies are members of St. Mary's Infirmary School of Nursing's first graduating class in 1936. To be admitted into the nursing program, students had to be a graduate from an accredited high school with a ranking in the upper one-third of the graduating class. The students also had to be between the ages of 17 and 25 years of age and "possess good mental and physical health." (Photograph courtesy of the Sisters of Franciscans.)

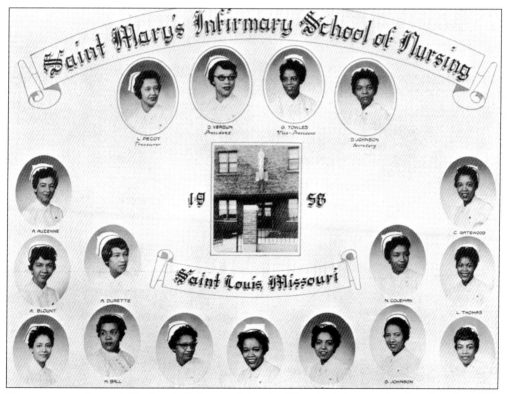

These are members of St. Mary's Infirmary School of Nursing's last graduating class in 1958. (Photograph courtesy of Sisters of Franciscans.)

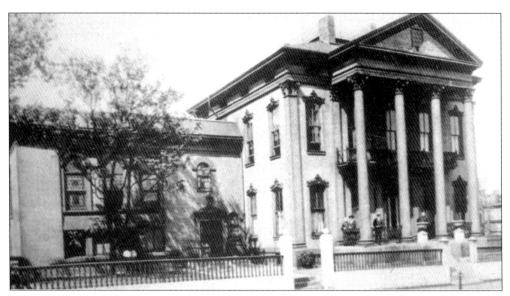

Although Roman Catholic parishes in St. Louis were never officially segregated, African Americans were often excluded from white congregations. In 1873, the refurbished Vinegar Hill Hall at Fourteenth and Gay Streets was dedicated as St. Elizabeth's Church for use by African Americans. The church moved to this facility at 2721 Pine Street in 1912. (Photograph courtesy of the Jesuit Midwest Regional Archives.)

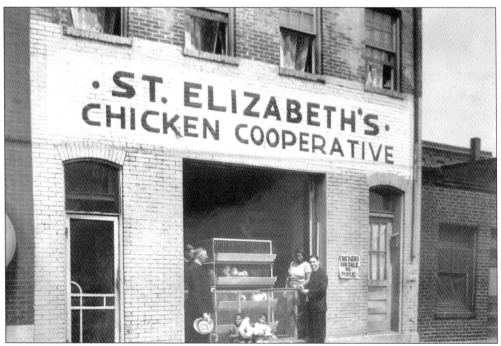

St. Elizabeth's Parish ¢operated a chicken and coal cooperative in the 1920s, which was open to the public. (Photograph courtesy of the Midwest Jesuit Regional Archives.)

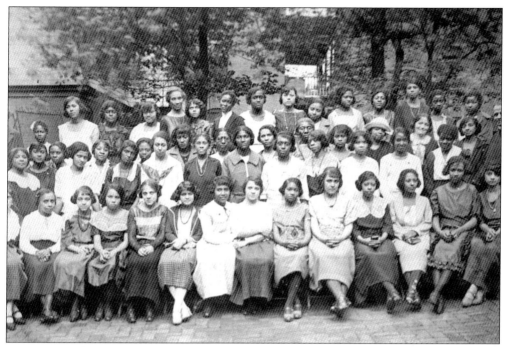

Since St. Elizabeth was the only parish opened to African Americans for years, it had a great deal of participation from its members in the use of its services and activities. These young ladies are participants in a 1918 woman's retreat. (Photograph courtesy of the Midwest Regional Jesuit Archives.)

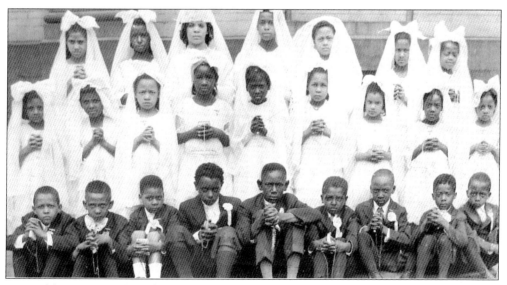

Pictured here are member of St. Elizabeth Parish's 1920-21 first communion class. (Photograph courtesy of the Midwest Regional Jesuit Archives.)

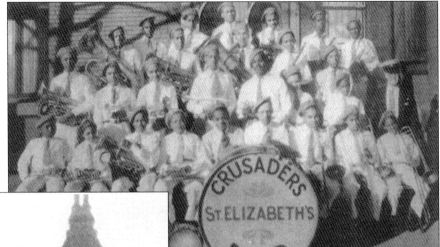

St. Elizabeth's Parish operated a school in this building at 901 N. Garrison Avenue. The parish's first school was started by the Oblate Sisters of Providence, an order of African American nuns in 1880. The school initially operated out of the church's basement. By January of 1881, however, they moved to a three-story house on Seventeenth Street. In 1883, they moved again to a larger building at Fourteenth and Morgan Streets. In 1911, the church was debt-free and moved its operations west to Mill Creek Valley, an area recently abandon by whites. Pictured next to the school is the parish band. (Photograph courtesy of the Midwest Jesuit Regional Archives.)

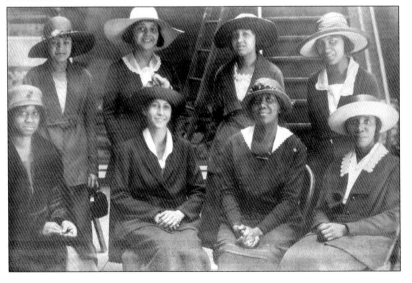

These ladies are members of St. Elizabeth's Parish's 1920 staff. (Photograph courtesy of the Midwest Jesuit Regional Archives.)

St. Nicholas at Nineteenth Street and Lucas Avenue is the first parish in St. Louis given by a white congregation to African Americans. Such transfers were common in many northern cities with burgeoning black populations, but not in St. Louis where St. Elizabeth's was the only parish available to African Americans until 1924. (Photograph courtesy of the Midwest Jesuit Regional Archives.)

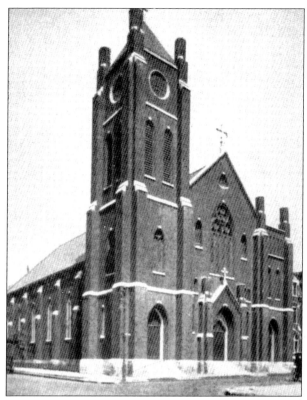

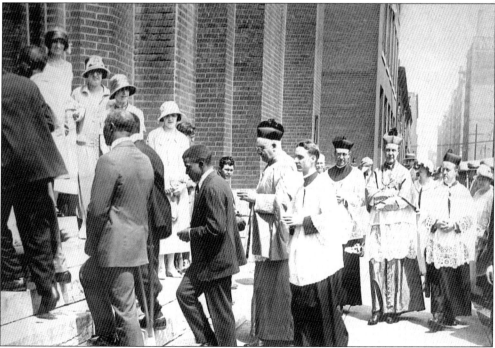

Members of St. Nicholas parish are shown here entering the church at its dedication to the African American community. (Photograph courtesy of the Midwest Jesuit Regional Archives.)

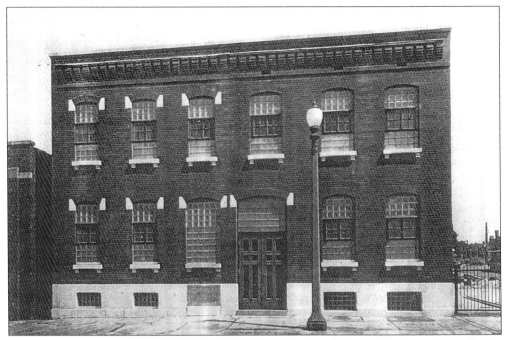

St. Nicholas parish operated an elementary and secondary school for African Americans, staffed by the Blessed Sacrament Sisters. The high school pictured here, used until 1961, was a converted four-family flat. (Photograph courtesy of the Midwest Jesuit Regional Archives.)

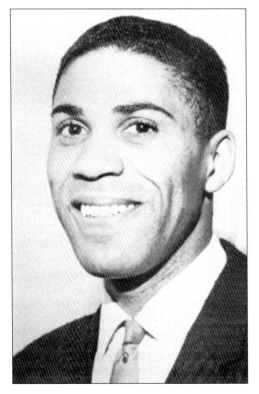

William L. Clay was one of St. Nicholas' outstanding graduates. Clay, after graduating from St. Nicholas' High School, went on to become a U.S. Representative where he served the community and country for over 30 years. He was very active in the civil rights movement in St. Louis, participating in sit-ins in restaurants and department stores, picket lines, and other peaceful protests. Clay also played a vital role as a member of the Board of Aldermen in having job discrimination abolished in St. Louis. (Photograph courtesy of the Midwest Jesuit Regional Archives.)

Second Colored Baptist Church (now known as Central Baptist Church) was formed in 1847. It has been and still is very involved in the community. Reverend Richard Sneethen was the first pastor, followed by John Richard Andersons. It moved to its present location in 1913. Reverend

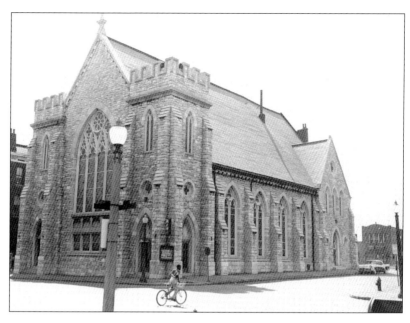

Anderson and Henry Maghee Alexander brought Masonry to St. Louis and set-up the first fraternal order of "Negroes" west of the Mississippi River. Reverend Anderson, along with several others, played a major role in getting the St. Louis public schools to serve African American youngsters. He served on the first and only Negro Board of Education in St. Louis. (Photograph courtesy of St. Louis University Archives.)

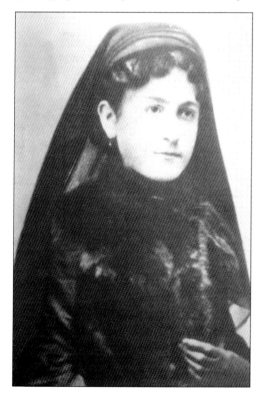

The St. Louis Colored Orphan's Home (now known as Annie Malone Children's Home.) was founded in 1888 by Sarah Newton, wife of Reverend J. S. Cohron, pastor of Central Baptist Church. Newton allegedly took a young orphan girl from the streets and placed her in a private home and paid for her care. Realizing that this was only a short term measure, Newton induced the members of the Harper Women's Christian Temperance Union to establish a permanent home for colored orphans of the city. (Photograph courtesy of John A. Wright.)

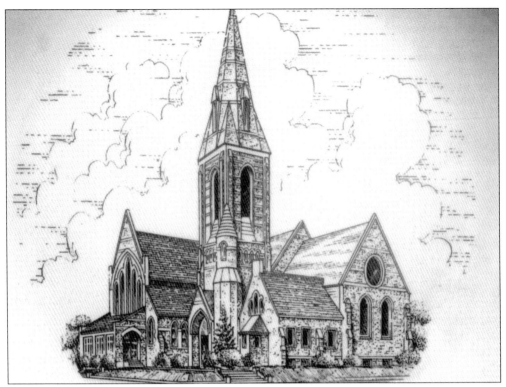

All Saints Episcopal Church, the first Episcopal Church for African Americans in St. Louis, was established in 1847. It began as a small mission, the Mission of Our Savior, at 1220 Morgan Street (now Delmar Boulevard). In June 1875, the mission moved to a building at Sixth and Cerre Streets and was renamed the Mission of the Good Samaritan. In 1883, the name changed to All Saints Episcopal Church. The church moved to the building pictured here in 1906 and remained until 1957. (Photograph courtesy of All Saints Episcopal Church.)

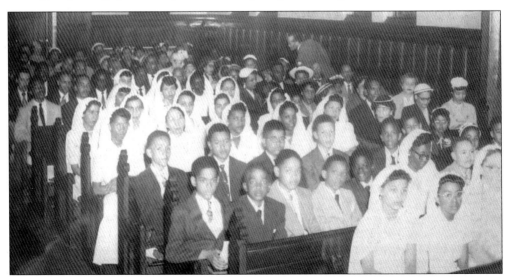

Pictured here are members of a 1954 All Saints confirmation class. (Photograph courtesy of All Saints Episcopal Church.)

Saint Paul Chapel AME, founded in the home of Priscilla Baltimore in 1841, was the first African Methodist church west of the Mississippi River. In the beginning the church meetings were necessarily clandestine and met in homes and blacksmith shops. The church, pictured here at 2800 Lawton Place at the time of construction, was the first church built for and by African Americans in St. Louis. Some of the early members of the church are pictured here at the bottom of the page. (Top drawing courtesy of John A. Wright and bottom photograph courtesy of St. Paul AME Church.)

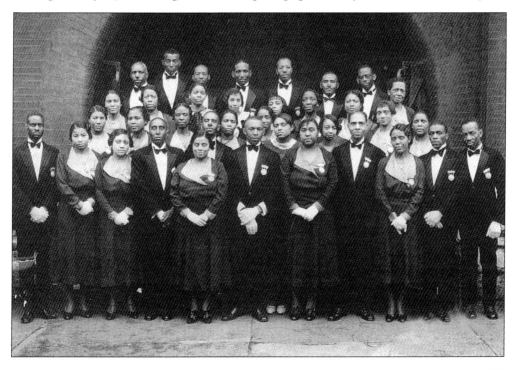

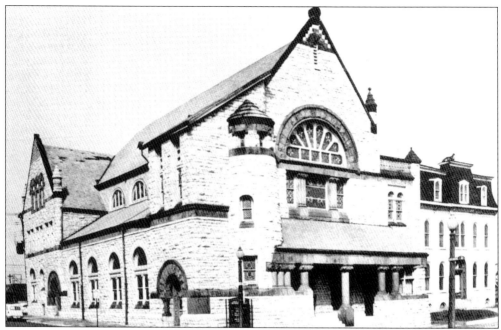

Union Memorial is the third oldest black Protestant church in St. Louis, and its history dates back to 1840, but the church was officially founded in 1846. The church had a white pastor until 1865. Originally, the congregation worshiped on Broadway between Morgan Street (now Delmar Boulevard) and Franklin Avenue in the home of a slave. Later the church moved to Seventh Street between Cass Avenue and O'Fallon Street, then to Green Street pictured here (now Lucas Avenue) in 1908, where it was called Little Rock Church. (Photograph courtesy of the St. Louis Landmark Association.)

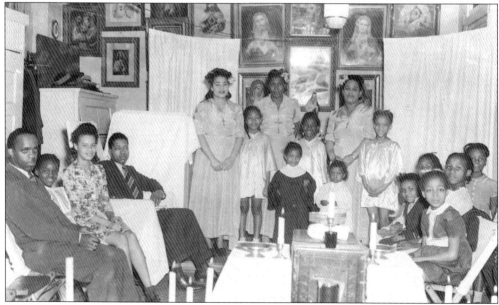

Along with the large major denominational churches in the community, there were numerous storefront churches such as the one shown here. (Photograph courtesy of John A. Wright.)

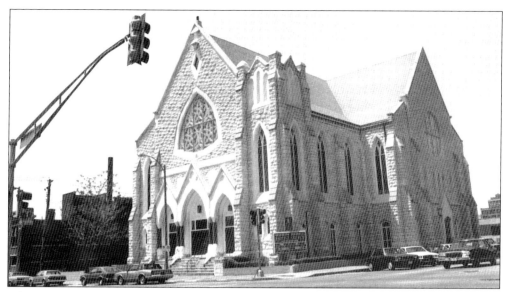

Tabernacle Baptist Church (now known as Washington Tabernacle Baptist Church) was organized in 1902 in the home of Sister May Brockman on Market Street. Reverend John Louis Cohran served as the church's first pastor. Worship for the church began in the True Reformer Hall at Jefferson and Pine Streets and grew from 35 charter members to 300. After several moves the church moved to its present location in 1926. The church was the site of a major civil-rights rally in May 1963, when Martin Luther King, Jr. drew more than 3000 participants to his Freedom Rally. (Photograph by John Wright.)

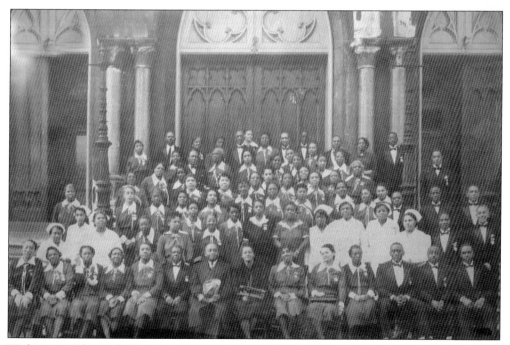

Washington Tabernacle Baptist has a very large and active membership. It is also the place of worship for many community and civic leaders. Some of the members are pictured here in front of the church. (Photograph courtesy of Washington Tabernacle Baptist Church.)

79

THE FRANKLIN DISTRICT NEIGHBORHOOD ASSOCIATION

908 ₿

An organization of taxpayers, business and professional men and women, parents, and interested citizens who believe in the future of this entire district.

The immediate reopening of Franklin School to elementary and intermediate white children is not only good business, but a square deal for the property owners and parents of this district.

> We believe in fair play; and in the policy of **LIVE AND LET LIVE**. We are not antagonistic to any group of citizens. We wish to help them. We do not ask to take anything **from** them. But we do ask—most emphatically—to **KEEP WHAT WE HAVE.**

This neighborhood is coming back to its former substantial quality. The critical situation facing us has brought together all sorts of organizations which will work for the **immediate restoration** of Franklin School as an elementary and intermediate school **for white children.**

Due to the widening of Franklin Avenue and other major improvements, we, the taxpayers and business men of the entire Franklin district have suffered keenly during the past two years. We have borne these difficulties and heavy expenses in the hope of future prosperity. Now, when we are at a point to realize on our investment, **IT IS UNFAIR TO CLOSE FRANKLIN SCHOOL TO ELEMENTARY AND INTERMEDIATE WHITE CHILDREN.**

> Many white families who were driven from this neighborhood, wish to return. We want them; we need them!!!

This district is convenient to good schools, good stores, good doctors, good churches and missions; Day Nursery; and unusual recreational facilities for boys and girls. Also there is a branch of the Community Music Schools Foundation (violin, piano and other instruments); and a modern Social Settlement with gymnasium, showers, meeting rooms, library, craft rooms, workshop, outdoor porches and outside playground. This is for the use of boys and girls, men and women.

> We are in the heart of St. Louis! Fifteen minutes from everywhere! The rents are reasonable.
>
> The reopening of Franklin School as an elementary and intermediate school for white children will help us rebuild this entire district.

"WE DO NOT WANT TO TAKE. WE WANT TO KEEP"

The Franklin District Neighborhood Association
and Associated Organizations

Vocational education was not always available to black students in St. Louis. The first vocational high school for blacks opened in September 1929, in Carr Lane Elementary School, which had been used formerly for white students. In 1937, the school was relocated to the Franklin Elementary School, another white elementary school. The Franklin District Neighborhood Association presented strong opposition to the school being given to blacks. They wanted to retain the school for white students. (Flyer courtesy of Washington University Archives.)

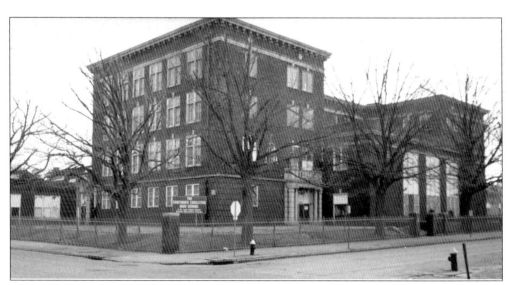

Washington Technical School, the former Franklin School pictured here, opened to blacks after the St. Louis Community Council, a municipal group with representatives from the AFL, the Chamber of Commerce, and the Urban League, took up the issue. The school could accommodate 1,100 students with its 16 classrooms, 12 shop rooms, a gymnasium, and an auditorium. The school closed after the 1954 Supreme Court *Brown v. Board of Education* decision. (Photograph by John A. Wright.)

We used this Location for the Pre-Ninth Grade Summer Institute - Project Chart.

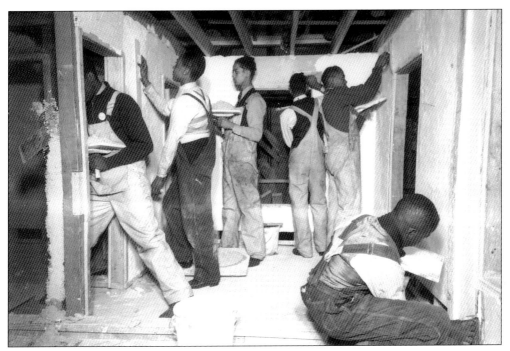

Washington Technical High School offered a wide variety of vocational programs for students in the trades and commercial area. These students are engaged in hands on exercise in building construction. (Photograph courtesy of the St. Louis Public School Archives.)

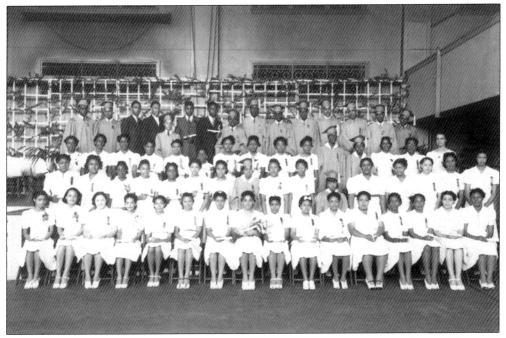

Washington Technical High School had a fairly good size graduating class each year. These are members of the June 1940 graduating class. Many of the school's graduates started their own businesses. (Photograph courtesy of the St. Louis Board of Education Archives.)

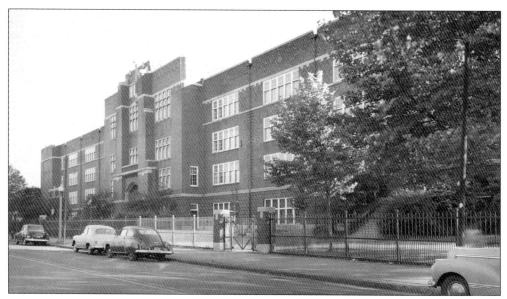

Vashon High School, pictured here, opened as an intermediate school in 1927, and four years later it became the city's second black high school. The opening of the school represented a major victory for black residents, who had been fighting since 1922 for a high school with a modern physical plant. Previously, black students had to travel to Sumner High School in north St. Louis. Vashon has many well known graduates such as Lloyd L. Gaines, Virgil Akins, Judge Theodore McMillian, Elston Howard, and Congresswoman Maxine Waters. The school relocated to the former Hadley Technical High School in 1963, and the site is now home for Harris-Stowe State College. (Photograph courtesy of the St. Louis Public Schools Archives.)

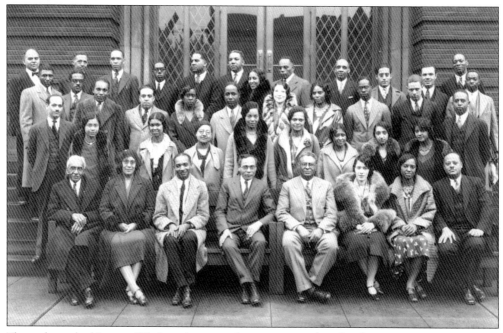

Throughout the history of Vashon, it attracted many outstanding faculty members. Pictured here are members of the 1931 faculty. (Photograph courtesy of the St. Louis Public School Archives.)

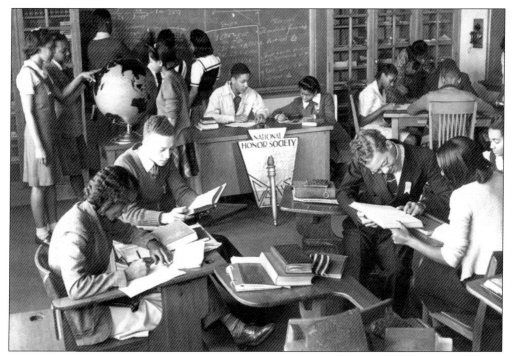

Because of the strong academic program offered to the Vashon students, many of them were able to excel in a variety of fields. These students appear to be hard at work during a study period. (Photograph courtesy of the St. Louis Public School Archives.)

One of the thrills of a Vashon event was the music from its marching band. Pictured here are members of the June 1937 marching band in front of the school as they prepare for an event. (Photograph courtesy of the St. Louis Public Schools Archives.)

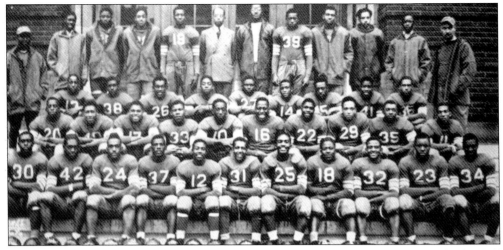

Vashon was known for its strong sports program. These are members of one the 1940s football teams. (Photograph courtesy of Vitilas "Veto" Reed.)

Maxine Waters, a 1955 Vashon graduate, is one of the many outstanding graduates of Vashon who have made their mark on the community, state, nation, and world. Waters, after graduation, went on to be elected in 1990 to represent the 29th District of California in the US House of Representatives, after 14 years as an elected member of the California Assembly from South Central Los Angeles. Today she represents a strong voice in the US House of Representatives who speaks out on issues involving the African American community. (Photograph courtesy of Wiley Price.)

Five

CHALLENGES AND OPTIMISM

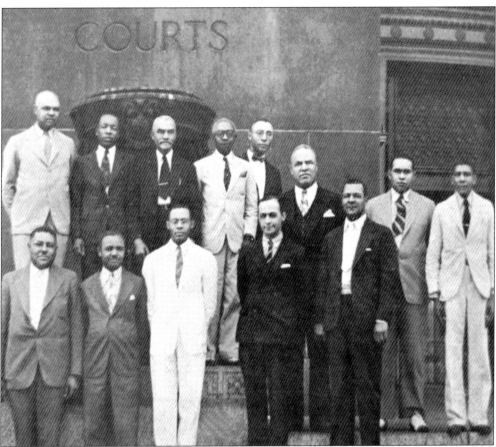

Despite the deplorable conditions many blacks found themselves in prior to the Civil Rights movement, there were few incidents of violence. Through peaceful protest and court action, the St. Louis community began to change. Blacks began to be elected to local, state, and national offices. Business and the news media began hiring blacks in key positions. Housing opportunities also began to open up. In 1959, the Reverend John Hicks became the first black to win a city-wide election when he won a seat on the school board. Theodore McNeal became Missouri's first black state senator and was joined by Raymond Howard in 1968. That same year William L. Clay was elected Missouri's first black Congressman. (Photograph of the Members of the Mound City Bar Association by Nathan Young, courtesy of the Western Historical Manuscript Collection, University of Missouri-St. Louis.)

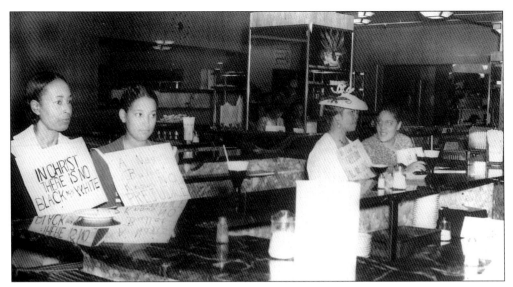

In early 1944, the St. Louis Board of Aldermen passed a law that integrated the lunchrooms at City Hall and other municipal buildings. Because of this new law, organizations became encouraged and began to organize to integrate the downtown department store lunch counters. On May 15, 1944, three black women and one white woman sat down at the Stix, Baer & Fuller lunch counter in an attempt to get the store to open its lunch counter to blacks without success. For the next two months African Americans demonstrated twice a week at the department stores. When 40 black and 50 white demonstrators sat at the counters of two stores in July, stores closed their restaurants to all rather than have them integrated. (Photograph courtesy of Mercantile Library.)

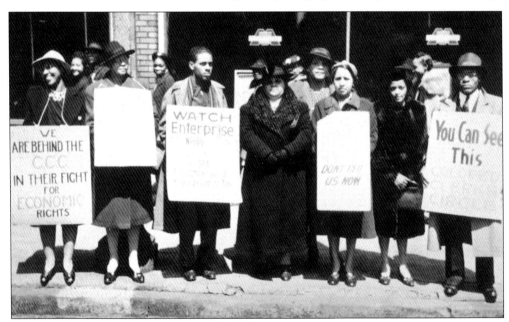

One of the major players in the effort to open up jobs for African Americans was the Colored Clerks Circle. This organization, working with the Urban League, pressured Woolworth on Franklin Avenue to hire African American clerks. (Photograph courtesy of the Western Manuscript Collection, University of Missouri-St. Louis.)

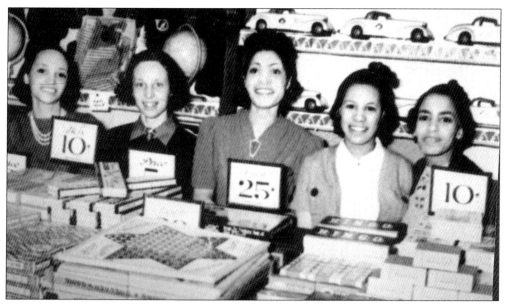

Pictured here are the first clerks hired by Woolworth Department Store on Franklin Avenue in the heart of the African American community. They are, from left to right, Ruby Cockrell, Helen Holloway, Evelyn Woods, Paris Jones, and Dorothy Bolar. These women, like many early sales employees of white business, had light complexions. The closer employees came to looking white the better their chances were for getting hired by white establishments it appeared. (Photograph courtesy of the Metropolitan Urban League of St. Louis.)

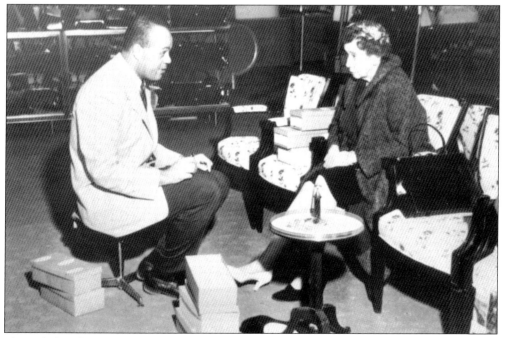

Through the efforts of the Urban League, this gentleman, who was once employed as a doorman, was moved up to become the store's first black salesman. (Photograph courtesy of the Urban League of Metropolitan St. Louis.)

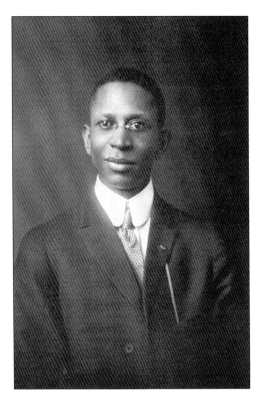

Along with jobs, housing was major issue in the African American community. In 1939, James T. Bush, Sr. a real estate broker with an office in the People's Finance Building, sold the property below at 4600 Labadie Avenue to J.D. Shelly and his wife. Shortly after they moved in, a suit was filed against them by their white neighbors on behalf of the Marcus Avenue Improvement Association, claiming their home was under a restrictive covenant based on race. (Photograph courtesy of Margaret Busch Wilson.)

The lawsuit against the Shelly's went all the way to the United States Supreme Court, which ruled in favor of the Shellys in 1948, and thus ended the use of restrictive covenants based on race all across America. However, despite the Shelly decision, a decade later the 95,000 blacks moving to St. Louis would find only 100 new homes available for them. This property where the Shelly family once lived at 4600 Labadie Avenue is now listed on the U.S. Registry of Historic Places. (Photograph by John A. Wright.)

Attorney George Vaughn, pictured here, successfully litigated the *Shelly v. Kramer* case before the U. S. Supréme Court that put an end to racially restrictive covenants as a legal consideration in the sale of housing. Vaughn was the first president of the Mound City Bar Association and editor of the *St. Louis Argus Newspaper.* He also served for many years on the executive committee of the St. Louis NAACP. In the 1920s, he worked within the Republican Party to campaign for black political candidates and black appointments to civil-service jobs. (Photograph courtesy of Murphy Park.)

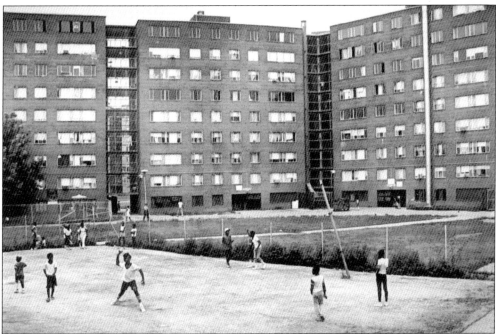

On April 28, 1957, this 660-unit housing project between Cass Avenue and Carr, Eighteenth and Twentieth Streets, was named for George L. Vaughn. It was torn down in 1995 and replaced with mixed-income housing. The official name of the new housing is Vaughn Residence at Murphy Park. (Photograph courtesy of the Mercantile Library.)

One of the most influential figures in St. Louis politics in the 1920s to the early 1960s was Jordon Chambers. Chambers was known by many as the black mayor of St. Louis and the father of black politics. During the 1930s, he led the exodus of blacks from the Republican Party into the Democratic ranks. Chambers was the Democratic committeeman for the city's nineteenth ward and constable in the old tenth district. He was also the owner of the Riviera, a nightclub at 4460 Delmar Boulevard. The Anchor Post Station was renamed for him in 1964, as well as a park at Compton and Franklin Avenues. (Photograph courtesy of Washington Tabernacle Baptist Church.)

Although the Shelly decision was an important one, the most important federal change to segregation in the 1940s came at the hands of Harry S. Truman who, led the way in abolishing segregation in the armed forces. On July 26, 1948, Truman issued the following order: "It is hereby declared to be the policy of the President that there shall be equality of treatment and opportunity for all persons in the armed services without regard to race, color, religion or national origin. This policy shall be put into effect as rapidly as possible. . . . " (Photograph courtesy of the Mercantile Library.)

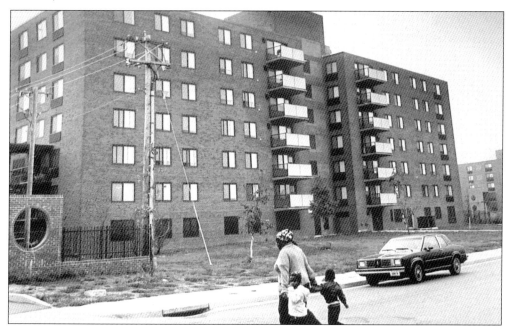

In 1952, an important case related to racial discrimination in public housing came up in connection with the St. Louis Housing Authority, which was responsible for operating and managing housing for low-income families. Although the law did not require racial segregation in housing, it was the practice of the city to separate families based on race in public housing units. After World War II, the Captain Wendell O. Pruitt projects on Jefferson and Cass were constructed for blacks, and the Cochran projects, pictured here, for whites. Due to a shortage of housing units for blacks, efforts were made by blacks for admission to Cochran. Their applications were always denied. (Photograph of the Mercantile Library.)

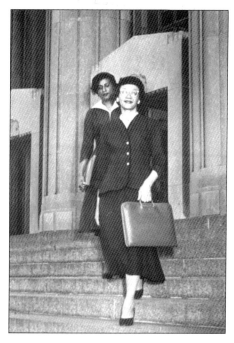

On June 20, 1952, attorney Frankie Freeman filed a class-action suit, *Davis et al v. the St. Louis Housing Authority*, in the U.S. District Court for the Eastern District of Missouri to challenge the city's practice of discrimination in public housing. On December 27, 1955, a decision was handed down that "forever enjoined" the St. Louis Housing Authority from "refusing to lease or rent to qualified Negro Applicants any units of public-housing projects… because of [their] race or color." (Photograph courtesy of Frankie Muse Freeman.)

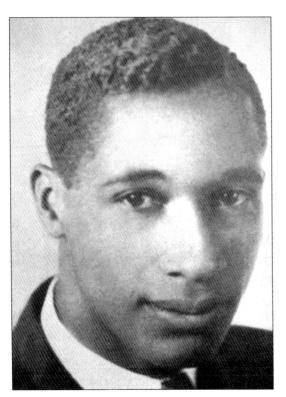

In 1931, Lloyd Gaines, pictured here, graduated first in his class from Vashon High School and enrolled in Stowe Teachers College. When he earned 26 credits, he transferred to Lincoln University in Jefferson City on a scholarship. After graduating from Lincoln, Gaines applied for admission to the University of Missouri's Law School. He was advised by the university to apply for an out of state scholarship. With the assistance of the National Association for the Advancement of Colored People, a legal team was assembled to represent Gaines to enable him to enroll in the University of Missouri's Law School. (Photograph courtesy of Lincoln University Archives.)

What happened to Gaines?)

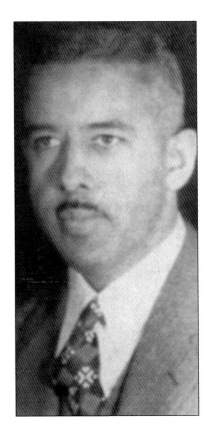

To represent Lloyd Gaines in his case against the University of Missouri, *Gaines v. Canada,* the NAACP chose Attorney Sidney Redmond to head a team of attorneys. The team took the case to the United States Supreme Court and won. But instead of admitting Gaines, the state passed a bill providing $275,000 for the establishment of Lincoln Law School in St. Louis. (Photograph by Nathan Young, courtesy of the Western Historical Manuscript Collection, University of Missouri-St, Louis.)

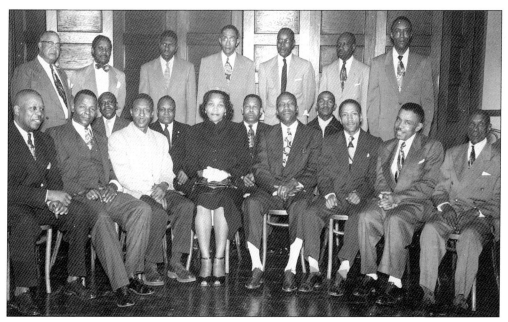

Because blacks were denied admission into white unions, they established their own. Pictured here are officers of 16 local lodges representing 14 railroads in the St. Louis and East St. Louis area during an installation in 1954. They are, from right to left: (front row) Thomas Ballard, Wm. Betts, James Wilborn, Beatrice Allen, Wm. Owens, B.L. Cole, I. Jones, and A. Strickland; (seated in the second row) A Shippings, N. Walker, J. Dancy, and Ike Gibson; (standing) L.L. Scruggs, Wilton Young, H. Franklin, R. Hert, Luther Emory, Wm. Scott, and Governor Jackson. (Photograph courtesy of John A. Wright.)

Although blacks played a vital role in the staffing of railroad dining cars, it wasn't until 1966 that a black was promoted to a steward in St. Louis. It was that year Jack Bracy, sixth from the left, became the first dining car waiter in the city to be promoted to steward. The position of steward (the director of the dining car) had always been given to white men. (Photograph courtesy of Jamie Graham.)

One of the key figures in the early Civil Rights movement was attorney David Grant. Grant played a major role during the 1940s in the picketing and boycotting of the stores along Franklin Avenue in the black community who refused to hire blacks. He also was a key figure in the case *The City of St. Louis v. Washington University,* as a friend of the court. Through his efforts, the university was forced to admit blacks or pay city taxes. Up until that time, the university was exempt from paying taxes. (Photograph courtesy of Mildred Grant and the Western Manuscript Collection, University of Missouri-St. Louis.)

Went to Wesh Univ the 60's with his daughter Gail 1967-70. Outs in grad school & she was an under grad. He represented the Black Students at Wash. U. during a sit-in in 69/70. I participated.

Dr. Martin Luther King spoke in St. Louis on several occasions. One of his early sermons was preached at Central Baptist Church in the early 1950s. He spoke again in 1957 at the Kiel Auditorium. In May of 1963, shortly before his March on Washington, he spoke at a freedom rally at Washington Tabernacle Baptist Church. The rally drew more than 3000 participants. It was part of a national effort to send a message to St. Louis and America that things had to change for African Americans, and they had to be given their civil rights. (Photograph courtesy of Central Baptist Church.)

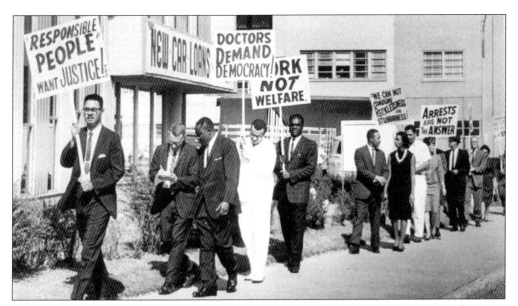

From August 30, 1963 until March 31, 1964, Jefferson Bank and Trust Company was the scene of a seven-month-long demonstration organized by the St. Louis Chapter of the Congress of Racial Equality (CORE) aimed at forcing the bank to hire four black clerical workers. Although the bank was in the heart of the black community and had a large number of black customers, it had no black clerks. The demonstrations ended in 1964 when the bank hired five black clerical employees. (Photograph courtesy of the Mercantile Library.)

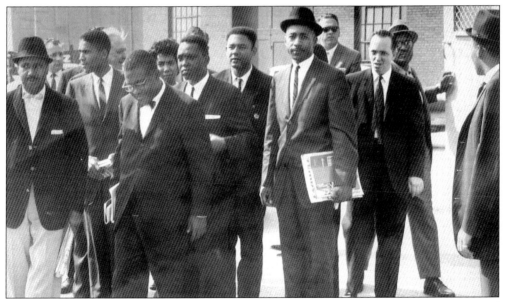

A number of the Jefferson Bank organizers were arrested, and the protests at the bank proceeded despite injunctions by the bank to halt them. Among those taking part in the protests were 26th Ward alderman William L. Clay, elected to the U.S. House of Representatives in 1968; Louis Ford, who was later a state senator; and community leaders Robert Curtis, who was then president of CORE; Norman R. Seay; Herman Thompson; Lucian Richards; and Charles and Marian Oldham. (Photograph courtesy of the Mercantile Library.)

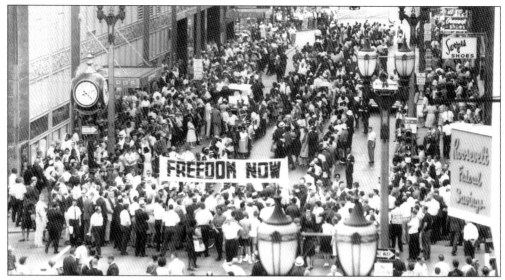

In June of 1963, the NAACP organized the demonstration shown here in front of the St. Louis Board of Education at 911 Locust Avenue, calling for the integration of the total school system. The school system was engaging in a practice of busing black students from over crowded black schools to white schools. Once the students arrived at the white schools, they were kept in separate sections of the building and given separate lunch and playground periods. (Photograph courtesy of the Mercantile Library.)

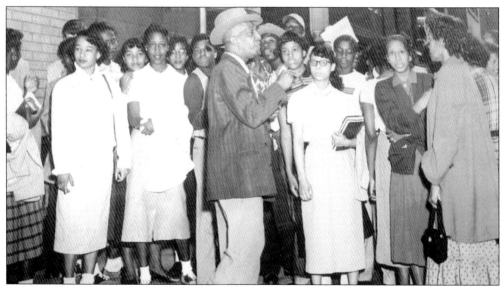

Henry W. Wheeler, a civil-rights activist, is pictured here with a group of students, encouraging them to end a protest. Wheeler fought discrimination in St. Louis, especially at the United States Post Office where he was employed for nearly 50 years. He became the leader of the all-black National Alliance of Postal Employees, an organization formed after the American Federation of Postal Workers refused membership to blacks. As a leader of the organization, he led demonstrations against post office policies that discriminated against black employees. Wheeler also worked to eliminate segregation in public places. He walked a picket line in front of the American Theatre for seven years until blacks were admitted. (Photograph courtesy of the Mercantile Library.)

On July 14, 1964, Percy Green and fellow activist Rich Daly focused attention on the lack of African American employment on the St. Louis Arch when they climbed the work ladder on the unfinished structure and chained themselves to it. Their action was one of the events that forced the United States Department of Justice to file its first "pattern or practice" suit against the St. Louis branch of the AFL-CIO Building and Construction Trades Council and four of its member unions for violation of Title VII of the Civil Rights Act of 1964. (Photograph courtesy of Mercantile Library.)

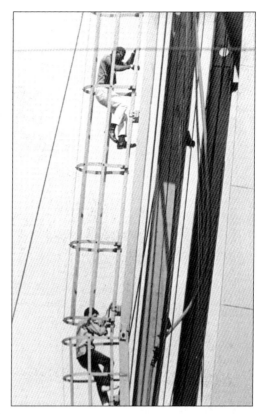

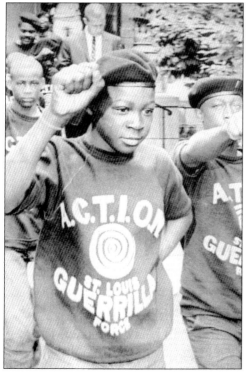

Pictured here are some of the young members of ACTION, an interracial human-rights group. ACTION was formed in the early 1960s, after a philosophical disagreement developed among the members of the St. Louis Chapter of CORE. According to ACTION's chairman, Percy Green, "Half of the organization wanted to go into community service, which was safe and did not cause confrontation. The other half wanted to remain active." (Photograph courtesy of the Mercantile Library.)

97

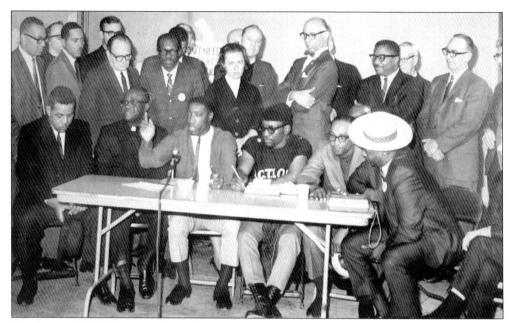

Members of ACTION are shown here presenting issues to community leaders. Although ACTION's methods were non-violent, they were confrontational. Their protest included climbing the Arch to protest contractor discrimination, deliberately tying up traffic on St. Louis highways and passing out leaflets telling drivers about unfair city practices, and demonstrating in churches and pointing out the responsibility of the church to eradicate racism in terms of employment. (Photograph courtesy of the Mercantile Library.)

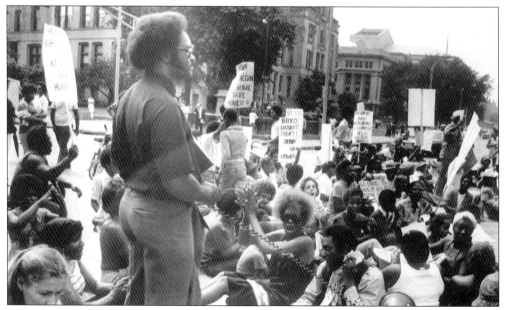

When discussions failed to yield results, community members often took to the streets to draw attention to their concerns. However, far too often many demonstrations were ignored by policy makers, causing deep divisions in the community among the races. (Photograph courtesy of the Mercantile Library.)

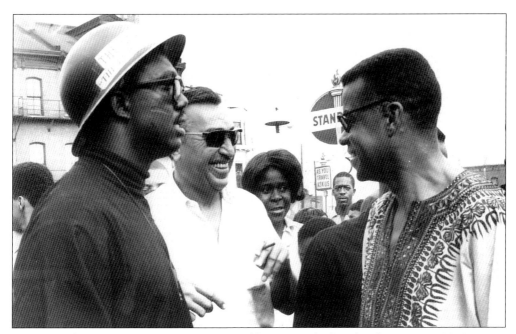

Members of the Black Liberators are pictured here outside their headquarters at 2810 Easton Avenue (now Dr. Martin Luther King) during a visit with Congressman Adam Clayton Powell. The organization. The Black Liberators, like many groups during the civil rights movement, were viewed as a threat. They were constantly underminded by law enforcement agencies that spared no efforts to make life difficult for the organization's members. (Photograph courtesy of the Mercantile Library.)

In baseball the system was not always fair to blacks or whites. For years players were treated as property that could be bought and sold. To address this problem, in 1970, Curt Flood, an outfielder for the St. Louis Cardinals with popular support among players, sued major league baseball to become a free agent. This was prohibited by the reserve clause, which was a part of the baseball player's contract. Flood lost the case in the U.S. Supreme Court on a technicality, but it ushered in a new financial era for professional ballplayers. (Photograph courtesy of Theodore Savage.)

During the long hot summers, the Pruitt-Igo housing projects were often the scene of unrest. Initially the housing project attracted national attention because it was supposed to have been one of the largest and best-designed public housing projects of the post-World War II period. The projects, once completed, quickly became a national scandal. It was viewed by many as a concentration camp without basic services. The 33 high-rise buildings were demolished in the 1970s. (Photograph courtesy of the Mercantile Library.)

During the 1960s, Sam "Boom Boom" Wheeler, a former Harlem Globe Trotter, could be seen in schools and on street corners outside supermarkets providing entertainment to youngsters. Wheeler spoke to children about sportsmanship, the value of education, and the need to stay in school. (Photograph courtesy of Betty Wheeler.)

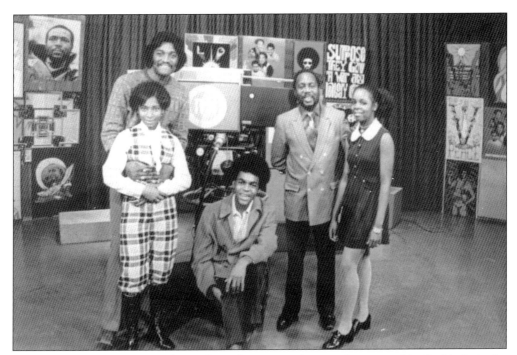

The Civil Rights movement in the city brought on some increased opportunities for blacks in the media. Television hosts Jim Gates and Bernie Hayes are pictured here in the Channel 30 studio during a taping of their show *Soul Brothers* in 1961. One of the goals of the show was to increase black pride and appreciation for black culture. (Photograph courtesy of Bernie Hayes.)

Sumner high school graduate Dianne White is known as a pioneer in breaking down racial barriers in St. Louis. In 1962, she became the first African American television meteorologist in the nation. Her career at KSDK-TV spanned more than 26 years from features to hard news. She was also the first African American model at major St. Louis department stores, including Stix-Baer & Fuller and Saks Fifth Avenue. (Photograph courtesy of Dianne White.)

Leo Cheers, pictured here with some fans, was one of the early jazz radio hosts on station KSD. Cheers is still going strong today. (Photograph courtesy of Bernie Hayes.)

Some of the early voices on radio station KATZ are pictured here with singer James Brown. From left to right are: (seated) Robert B.Q. Burris and Doug Easton; (standing) Chuck Cunningham, James Brown, Bernie Hayes, Jerome Dixon, and Buster Jones. Radio station KATZ -1600 began on January 3, 1955, providing an invaluable voice to the voiceless by hiring African American announcers to play the latest popular and religious music. Some of the other early station personalities included Jesse "Spider" Burks, Rodney Jones, Lou "Fatha" Times, Willa Mae "Gracie" Gracey, Gabriel, Al Waples, Ken Brantley, "Gentleman" Jim Gates, Donnie Brooks, and John O'Day. (Photograph courtesy of Bernie Hayes.)

One of the best-known faces on television was Julius Hunter, who began his broadcast career in 1970 as a news reporter, weekend anchor, and weekend news director of KSD-TV. He is one of the few journalists in the nation who has conducted exclusive television interviews with five U.S. presidents: Bill Clinton in 1994, George Bush in 1991 and 1992, Ronald Reagan in 1982, Jimmy Carter in 1979 and 1987, and Gerald Ford in 1975. Hunter has covered popes, both in America and in Italy. Besides being an accomplished broadcaster, Hunter is also an author, columnist, and music composer. Hunter retired as a new anchor for KMOV-TV in 2002. (Photograph courtesy of Virginia Publishing Company.)

Went to St. Louis U. Was a R.A. at Wash U while I was their. His Daughters went to Burroughs & Sherrie & 'Funmi went to Country Day (MICDS)

COOASCO

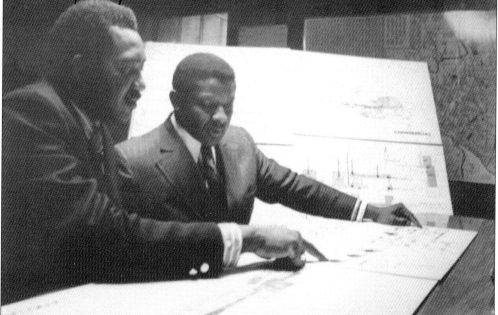

Under the leadership of Harold Antoine, the Human Development Corporation during the 1960s, 70s, and 80s provided a number of programs to assist the African American community in the areas of employment and job training, education, and community development. Antoine, on the right, is pictured with realtor Elijah Brown reviewing a proposal for redevelopment in downtown St. Louis in the 1960s. (Photograph courtesy of Harold Antoine.)

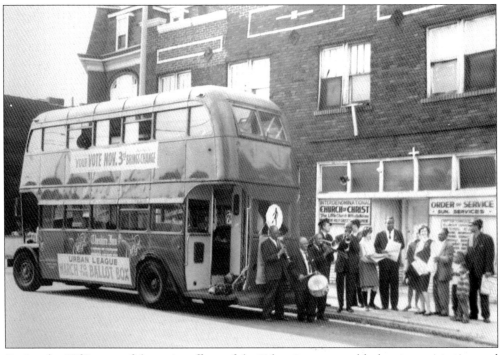

During the 1960s, one of the major efforts of the Urban League was black voter registration and voting. The results of these efforts paid off with the election of a number of blacks to political office. (Photograph courtesy of the Urban League of Metropolitan St. Louis.)

When Gwen Giles was elected to fill the unexpired term from the State's Fourth District in 1977, she became the first black woman elected to the state senate. She was subsequently elected the following year for a full term. Giles sponsored an unsuccessful bill to ratify the Equal Rights Amendment in 1979 and a successful bill to increase general and relief payments. Giles resigned her position in 1981 to become the first African American to be appointed assessor for the city. (Photograph courtesy of Miki Brewster.)

Wasn't she murdered by her son-in-law?

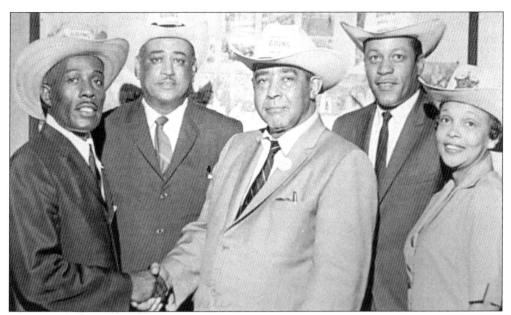

In 1968, Benjamin Goins became the first African American to hold a citywide office when he was appointed St. Louis license collector by Governor Warren E. Hearnes. In 1977 he became the first African American to be elected to a citywide elective political office when he became sheriff. He was later forced to vacate the position because of legal difficulties. Goins, on the left, is seen here shaking hands with Ernest Callaway, who played a major role in the election of Reverend John J. Hicks in 1959 to the St. Louis city school board, T.D. McNeal to the state senate in 1960, and his wife, DeVerne in 1962. She became the first black woman to serve in the Missouri state legislature. (Photograph courtesy of the Western Manuscript Collection, University of Missouri-St. Louis.)

Didn't he go to prison?

In 1960, Theodore McNeal became the first black elected to the Missouri state senate. McNeal was active in union politics, having served on the national staff of the Brotherhood of Sleeping Car Porters and Maids Union since 1937. He served in the senate until 1977 when he decided not to seek reelection. He was named to the University Of Missouri Board Of Curators in 1971 by Governor Warren E. Hearnes and named president of the St. Louis Board of Police Commissioners in 1973 by Governor Christopher S. Bond. (Photograph courtesy of Betty Wheeler.)

Theodore McMillian in 1956 became the first black circuit judge in Missouri's history when he was appointed to the bench by Governor Phil M. Donnelly. McMillian, a Vashon High School graduate, graduated at the top of his class from St. Louis University. He served a number of years as an assistant St. Louis circuit attorney where he earned a reputation as a brilliant trial lawyer. In 1972, he was appointed to the Missouri Court of Appeals by Governor Warren E. Hearns, and in 1978 he was appointed to the United States Eighth Circuit Court of Appeals by President Jimmy Carter. (Photograph courtesy of the Mercantile Library.)

One of the outstanding figures of the 1970s and 80s was John Bass. Bass, a graduate of Sumner High School, after college returned to the St. Louis school system to teach and moved up to become principal of Beaumont High School. He moved on to work at City Hall as the director of human resources. In 1973, with the help of the Pipe Fitters Union, he was elected comptroller of St. Louis. In 1980, he was elected to the state senate, a position he held until 1991 when he stepped down. Bass is pictured here in his office with Debbie Turner, Miss America and St. Louis television personality. (Photograph courtesy of Senator John Bass.)

From Missouri although her home was Arkansas. attended U M - Columbia

Long time civil rights leader and former Aldermen of the Fourth ward, Joseph Clark was appointed director of public safety by Mayor James Conway in 1977. Clark ran unsuccessfully to become President of the Board of Aldermen. It is reported that after he failed to gain the presidency of the Board of Aldermen, he decided to run again for his seat as Alderman. Having passed the deadline to be placed on the ballot, Clark used a rubber stamp to put his name on ballots for residents to use at the poll and won the election. (Photograph courtesy of *Newsgram,* City of St. Louis.)

The Civil Rights Movement marked the beginning of a time when African Americans could attend concerts at establishments where they once were only allowed to perform. Musicians like Singlton Palmer, pictured here, was one of many who brought joy to the whole community and carried on the tradition of jazz that began in the steamboat era with Louis Armstrong, Fate Marable, W.C. Handy, and the left-handed fiddler named Tabeau. (Photograph courtesy of the Mercantile Library.)

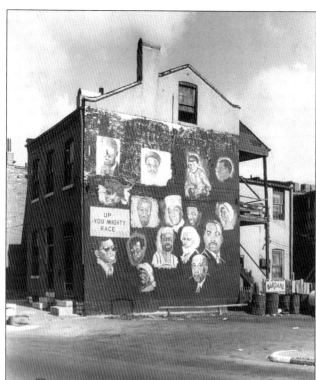

The events of the 1960s brought out a sense of pride in the black community that began to show in dress, hair styles, and attitudes toward blackness. This mural depicts several black heroes who have made contributions to the black race. (Photograph courtesy of the Mercantile Library.)

I remember seeing this. Where was it located??

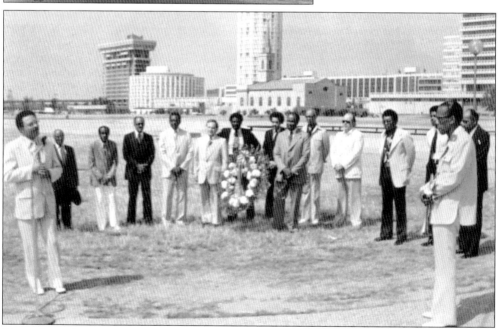

Throughout the years there are those who will always remind us that we must not forget the past and the contributions made by those who have paved the way for a brighter tomorrow. Pictured here are members of the Frontier's at their annual memorial service on the riverfront for the slave York who saved the village of St. Louis from the British and the Indians in 1789. (Photograph courtesy of Harold Antoine.) *Do we still remember?? sus 5/7/08*

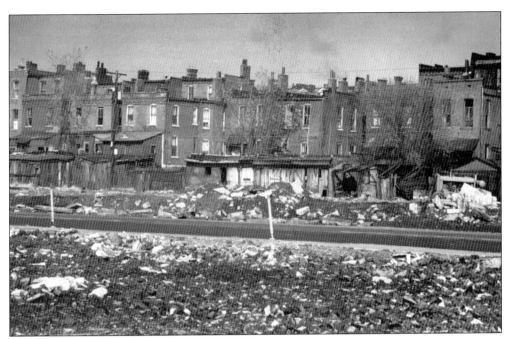

By the 1950s, time had taken its toll on the African American community in downtown St. Louis, as can be seen in this photograph. Many of the homes and businesses that once served the community were removed for good. Some homes were replaced by housing projects that are now making way for long-awaited decent housing. (Photograph courtesy of the Missouri Historical Society.)

I arrived at Wash U, in Aug/Sept 1967. Never saw anything like this??

Although nearly all of the businesses that once thrived in the segregated world of downtown St. Louis have disappeared from the landscape, former residents will long remember such places as Peacock Alley, where they could see and hear some of the top names in the entertainment world. (Photograph courtesy of the Black World History Museum.)

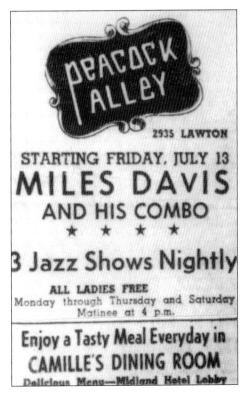

Many African Americans who once lived in downtown St. Louis have moved on to become famous and well-known personalities. However, they almost always come home at some time to visit. Maya Angelou who lived at 2714 Caroline Street and attended L'Oveture Elementary School, has returned to St. Louis many times. She is an actress, author, and educator. Her poem "On the Pulse of the Morning" was read on January 20, 1993 at the inauguration of President William Jefferson Clinton in Washington, D.C. (Photograph courtesy of the Mercantile Library.)

Roy Wilkins, who lived at 2818 Laclede Avenue during his early life, would often return to his childhood hometown. Wilkins attended Banneker Elementary School. He later moved to St. Paul, Minnesota and later became a civil rights leader and executive secretary for the NAACP. Wilkins also was the managing editor of the *Kansas City Call* prior to his joining the NAACP as the editor of *Crisis*, its official magazine. In May 1945, he served as a consultant to the American delegation that helped found the United Nations. Wilkins on the left is pictured here with Governor Joseph Teasdale, attorney Frankie Freeman, and community leader Fredda Witherspoon. (Photograph courtesy of the Mercantile Library.)

Six

SIGNS OF PROMISE

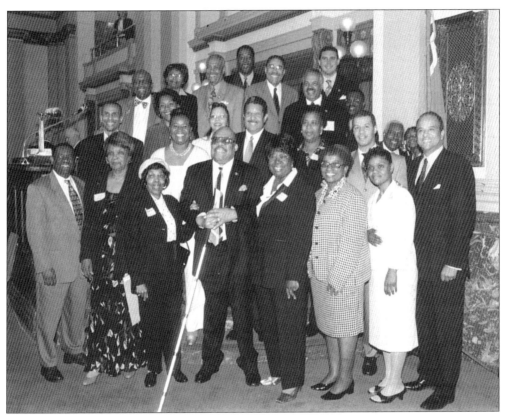

Today, blacks can be found participating in many aspects of the downtown community. No one can deny that today's climate is a far cry from earlier years, when almost every aspect of city life was segregated, from the birthing room to the cemetery. Restaurants, hotels, bars, and housing units are now open to those who can afford to use them, regardless of color. Most of the rundown housing units and schools have been replaced. Hospitals will take blood from healthy givers with no regard to race. It is not rare to see an African American elected to some state and local positions. One is also not surprised to see blacks in administrative positions or in leadership roles. However, no one should say or think that things are where they should be. Never the less, the progress that has been made thus far gives signs of hope for the future. (Photograph courtesy of *Newsgram,* the City of St. Louis.)

In 1993, Freeman Bosley, Jr., on the left, became the city's first black mayor in its 229-year history, winning with 67 percent of the vote. Prior to being elected mayor, he was elected clerk of the circuit court of St. Louis in 1982. This office had 200 employees and an annual budget of over $40 million. Clarence Harmon, on the right, became the city's second black mayor in 1997. In 1990, when he was appointed secretary to the St. Louis Police Board, he became the first black in that position in the 129-year history of the police department. The following year he was appointed the city's first black chief of police, over a department where he had served for 21 years. (Photograph courtesy of *Newsgram*, the City of St. Louis.)

Virvus Jones began his political career as a member of the Board of Aldermen in 1981, where he served until 1985. He was later appointed assessor for the city in 1986 and remained in that position until 1988, when he was appointed city comptroller. The following year he ran for the position and was elected for a full term. He remained in the position until 1995. During Jones' tenure as comptroller he fought to get minorities a fair share of city contracts. (Photograph courtesy of *Newsgram*, City of St. Louis.) He falsified his resume when the ran for a later office

In 1991, Sherman George became the city's first black fire chief. George had a distinguished career with the fire department. While the youngest captain in the fire department, he became the city's first black chief instructor at the Fire Academy since its inception in 1857. As the chief instructor, George was in charge of all training programs for the entire fire department and new recruits. Before becoming fire chief, George served as a battalion chief and deputy chief. (Photograph courtesy of *Newsgram,* City of St. Louis.)

Unjustly removed from his position in 2007 by mayor Slay. Wife between at Stix Baer & Fuller at Westroads for shopping while Black. Later Dillards at Galleria.

Ronald Henderson and Edward Tripp brought to their positions many years of outstanding service. Tripp, on the right, served as the director of public safety from 1993-97. Prior to assuming that position he served in a variety of positions for the city and state in the areas of juvenile and criminal justice and public welfare. Henderson, on the left, after more than 30 years of service in the police department moved up through the ranks to become the city's second African American police chief. He retired in December of 1995 and served as secretary of the Board of Police Commissioners for five months. In 2001, Henderson was appointed U. S. Marshal for Eastern Missouri by President George Bush. (Photographs courtesy of *Newsgram,* City of St. Louis.)

Vashon High School and Washington University graduate Darlene Green presently serves as the Comptroller of the City of St. Louis, a position she has held since first being appointed in 1995 and later elected in 1996. Prior to her election, she worked as a budget director and finance manager for the City. During her tenure as budget director, the City achieved a fund balance surplus in both years. Wall Street bond rating agencies recognized these successes and elevated the city's credit rating for the first time in 20 years. (Photograph courtesy of *Newsgram,* City of St. Louis.)

Still in office 5/17/08

On April 23, 1981, Larry Williams became the first African American treasurer for the City of St. Louis, a position he has held for 22 years. As treasurer he is over the City's banking and investment operations, which consist of $1.5 billion a year. He is also custodian of the Fire and Police Retirement Systems. As treasurer, Williams is also responsible for the City's parking authority, which under his leadership has gone from a $300,000 a year operation to its current level of $12,000,000 a year. Williams received his B.A. degree from the University of Wisconsin. (Photograph courtesy of *Newsgram,* the City of St. Louis.)

114

Today African Americans can be found at most levels of the legal system. Pictured here are some of the black judges that serve the city, state, and region. They are, from left to right: (seated) George Draper, Missouri Court of Appeals; Henry Autry, U.S. District; Carol Jackson, first black Chief Judge for the federal district of St. Louis, U.S. District; Theodore McMillian, first black, U.S. Court of Appeals for the Eighth Circuit; Charles Shaw, U.S. District; Ronnie White, first black, Missouri Supreme Court; Booker Shaw, Missouri Court of Appeals; (standing) Angela Turner Douglass, Circuit; Donald McCullin, Circuit; Michael Calvin, Circuit; Daniel Tillman, second black Circuit; Evelyn Baker, first black female Circuit in Missouri; Barbara People, Associate Circuit; and Jimmie Edwards, Circuit Judge. (Photograph by John A. Wright.)

Members of the St. Louis Black Leadership Roundtable (SLBLR), pictured here, are some of the most influential African Americans in the City of St. Louis. Their organization comprises representatives from almost every walk of life including business, education, media, civic, religious, medical, law, and volunteer sectors. The SLBLR is a very strong force in the community, speaks out on key issues that impact the black community, and tries to work for amicable solutions. (Photograph by John A. Wright.)

African Americans like John Moten, the former senior vice president of operations and marketing at Laclede Gas, can be found today in all levels of many corporations. Moten was in charge of the departments that ran 24 hours a day, seven days a week and 365 days a year. Seventy-five percent of the company's employees worked under his supervision. Laclede Gas is the largest natural gas distribution company in Missouri and serves more than 630,000 natural gas customers in St. Louis and surrounding counties in Eastern Missouri. (Photograph courtesy of John Moten.)

Superintendent Cleveland Hammonds, second from the left, has been the chief officer for the St. Louis Public Schools since 1997. The district is one of the largest employers in the city with more than 6,000 employees. It is also the largest school system in the state with a student population of over 40,000 and an annual budget of almost a half billion dollars. Under Hammonds' leadership there has been a dramatic decrease in the dropout rate and an increase in the number of students completing school. Hammonds also has led the successful bond issue campaigns for millions of dollars for new construction and school improvement. (Photograph courtesy of the St. Louis Public Schools.)

116

Chancellor Henry Shannon, Ph.D. of St. Louis Community College oversees the largest community college in the state of Missouri and the second largest institution of higher education in the state. St. Louis Community College has more than 3,500 full and part time employees, a budget of $130,000,000, a student population of more than 140,000 students in credit and non-credit courses on three main campuses, four education centers, and scores of locations in the community. Dr. Shannon became chancellor of the college in January of 2000, after serving as interim chancellor in 1998 and 1999. (Photograph courtesy of St. Louis Community College.)

Left for CA in Fall, 2007.
I retired 12/21/07 from SLCC - Meramec
Started at SLCC-FV in Fall of '70

Harris-Stowe State College, St. Louis city's only four-year public institution of higher education, has operated under the leadership of President Henry Givens, Ph.D. since 1978. Prior to coming to the institution, Givens served as the deputy commissioner for Urban Education for the Missouri Department of Elementary and Secondary Education. He also established one of the first magnet schools in the country as a principal in the Webster Groves School District. Under Givens' leadership, the College's enrollment has grown from 800 students in 1979 to 1,992 in 2002. Its degree programs have increased from one to 12, and its facilities from one building on 9 acres to four buildings on 33 acres, with plans for future development. (Photograph courtesy of Henry Givens.)

He's still there!

[handwritten left margin: S.O. grad including at 1 year teen of Alumni at NSPim, D.C. was 5/7/08]

117

Cordell Whitlock

Gone

Kelly Jackson

Art Holliday

Sharon Stevens

Malcolm Briggs

Gone to National – ESPN??

NEWSCHANNEL **5**

Gone are the days when African Americans could only see their image on such shows as *Amos and Andy* and *Beulah*. Today they can be seen on all the major television stations presenting the news and informational programs. Above are some of the African American reporters for KSD-TV. Many bring with them years of experience. (Photograph courtesy of KSD-TV.)

A couple of outstanding reporters, Vickie Newton and Robin Smith can be seen daily on KMOV-TV, presenting the news to the community. Newton, left, although new to the community, brings to the job a great deal of professionalism. Smith is a well known news' professional and a St. Louis favorite. (Photograph courtesy of KMOV-TV.)

Today African Americans can be found in a variety of positions working at the *St. Louis Post Dispatch* newspaper. Pictured here are some of the staff. They are, from left to right: (front row) Gary Hairlson, assistant photograph director; Coddy Murry, administrative assistant; Lorraine Kee, reporter-columnist; Denise Hollinshed, reporter; Lisa Townsel, fashion editor; Cleora Hughes, food writer columnist; Annette Reaviling, executive assistant to the managing editor; Norm Parish, reporter; Kevin Boone, sports reporter; and Bob Joiner, editorial writer; (back row) Yvonne Samuel, education reporter; Patrick Thimangu, business reporter; D. Paul Harris, reporter; Odell Mitchell Jr., photographer; and Kim Taylor, community news writer. (Photograph courtesy of the *St. Louis Post Dispatch.*)

Today excellent educational facilities and programs can be found throughout the downtown area to serve residents. Pictured on pages 120 and 121 are a few: on page 120 at the top is Pruitt Military Academy at 1212 North Twenty-second Street, named for Wendell Pruitt, an African American World War II hero; in the center is Blewett Middle School at 1927 Cass Avenue, named for Ben Blewett, a former school superintendent; and at the bottom is The Samuel Shepard Jr. Gateway Educational Park on Gateway Drive, named for Dr. Samuel Shepard, Jr., an outstanding African American administrator. (Photographs by John A. Wright.)

On the top is Dunbar Elementary School at 1414 North Garrison Avenue, named for Paul Lawrence Dunbar, an African American poet; in the center is Jefferson Elementary School at 1301 Hogan Street, named for President Thomas Jefferson; at the bottom is Waring Elementary School at 25 S. South Compton Avenue, named for Oscar Waring, a lawyer and teacher who became the first black principal of Sumner High School in 1879. (Photographs by John A. Wright.)

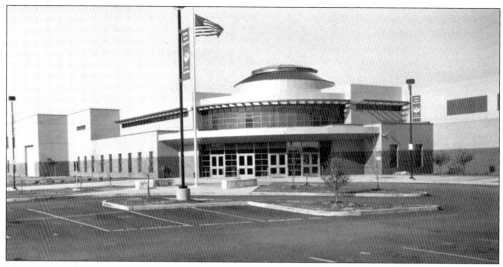

The new Vashon High School at 3035 Cass Avenue now stands ready to produce the next generation of leaders as it has in the past. This $40,000,000 facility had an enrollment of 1081 when it opened in the 2002-03 school year. (Photograph by John A. Wright.)

Was it truly needed? Arent they having H₂O problems

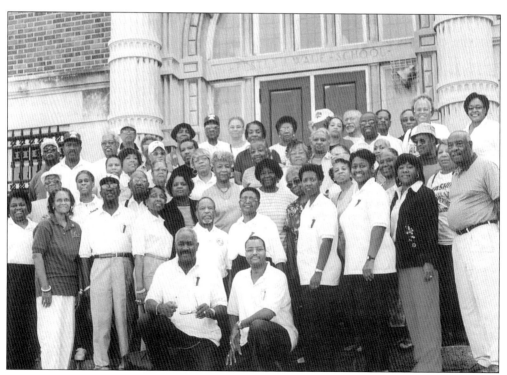

The Members of the Unified Vashon Alumni Association, pictured here, remind us of the school's proud past and unlimited future. (Photograph courtesy of Vitilas "Veto" Reid.)

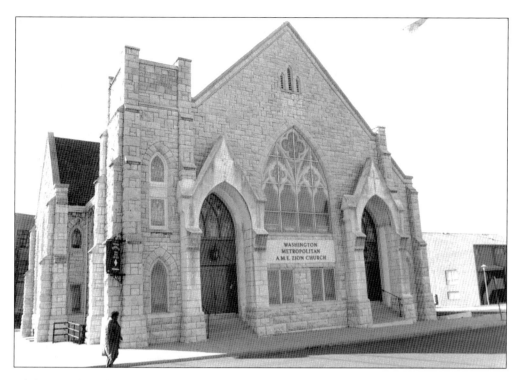

While a number of churches moved to other parts of the city during the 1950s and 60s, a number remained, such as Prince of Peace Missionary Baptist Church, Calvary Baptist Church, Central Baptist Church, St. Nicholas Catholic Church, Berea Presbyterian Church, Jamison Memorial Methodist Church, and Washington Metropolitan African Methodist Episcopal Zion Church, to serve the community. Washington Metropolitan AME Zion, pictured here at 613 North Garrison Avenue, was organized in 1870 and decided to remain when most of the area around it was being demolished. Under the leadership of Reverend Richard Fisher, the church sponsored the construction of the nearby Lucas Heights (pictured below) and Metropolitan Village housing units of rental apartments and townhouses built in the 1980s. (Photographs by John A. Wright.)

Berea Presbyterian Church at 3010 Olive Street has remained an anchor on the western end of the downtown district. Berea was organized in 1898 as a black congregation. During the 1960s, it became a racially mixed congregation, drawing a number of white families into the church. Civil rights organizations used the church as a gathering place, and members participated in civil rights demonstrations. (Photograph by John A. Wright.)

Having served the community for more than 60 years, the Carver House Center at 3035 Bell Avenue remains a vital institution in the downtown African American community. The center opened in 1939 in a Bell Avenue Mansion. By 1957 the center was serving more than 43,000 children and adults each year. The current building opened in 1958 on the same lot as the original facility. In 2001, the center, a United Way agency, served more than 580 households, representing some 1,500 people with social services, after-school programs, and crisis intervention for families and youth. (Photograph by John A. Wright.)

New housing units can now be seen throughout the area, providing decent dwellings for residents. At the top of the page are the new remodeled units at Carr Square Village and below are the new units at Murphy Park. (Photographs by John A. Wright.)

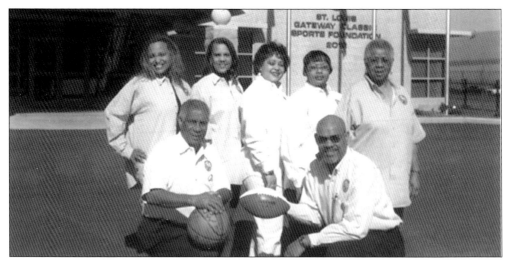

The St. Louis Gateway Classic Foundation recreation and office facility is one of the newest additions to the downtown area. Almost 70 percent of the work was done by African American firms. The facility has banquet and reception space sufficient to accommodate more than 600 people. The individuals pictured here are the moving force behind the center's activities, from left to right: (front row) Earl Wilson Jr., C.E.O. and founder, and Arthur Tyler Jr.; (second row) Dedree Smart, Melba Young, Sherry Stennis, Edwina Slater, and Irene Hughes. (Photograph courtesy of Earl Wilson.)

A Diamond Walk of Fame is part of the St. Louis Gateway Classic Foundation complex. The Diamond Walk of Fame honors outstanding African American St. Louis residents. Among those inducted into the first Diamond Walk of Fame were Jackie Joyner-Kersee; Freeman Bosley Jr., the city's first black mayor; Congressman Will Clay Sr.; The 5th Dimensions; political activists Perch Green and Dick Gregory; Elston Howard, the first black New York Yankee; Nanny Turner, the first black female publisher in Missouri; Roscoe Robbins, the first black four-star U.S. Army General; and Congresswoman Maxine Waters. (Photograph by John A. Wright.)

Postscript

In 1994, Mayor Freeman Bosley Jr. of St. Louis, Missouri, and Mayor Abdoulaye Chimere Diaw of St. Louis, Senegal in West Africa, joined hands to form the bonds of brotherhood between the two cities. It was from West Africa that most of the ancestors of African Americans in the St. Louis community came. This event in a way marked the completion of a circle for African Americans and one of the many outward signs that can be seen in the community to demonstrate that color can no longer be used as a means to create divisions. The city, nation, and world in order to reach their highest potential must be open to all, regardless of color. As it has been said, "No one of us is as smart as all of us." (Photograph courtesy of the St. Louis Center for International Relations)

There is no question that St. Louis is a far better place to live for African Americans than it was 100 years ago or even 50 years ago. Restaurants, hotels, recreational facilities, hospitals, schools, and even cemeteries are open to all regardless of color. Yet St. Louis remains one of the most segregated cities in America according to recent reports. African Americans still have difficulty getting loans for homes and purchases. Many companies still discriminate in hiring and promotions. There are questions about the inequities in the delivery of justice regarding African Americans in the criminal justice system. There also remain major concerns about the reporting and the handling of events in the African American community in the media and the promotion of stereotypes.

Racism is a business—one that takes advantage of both blacks and whites. Many on both sides become losers. We all must learn that we are more alike than different, and St. Louis will only become great and reach its full potential when everyone is allowed to sit at the table. Only by working together can we build a bright tomorrow for all our children. The future is in all our hands. (Photograph by John A. Wright)